PocheCouleur

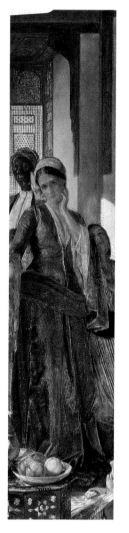

In the same series :

* Also available in English

Artistic Director: A.-Chaouki Rafif
Documentation: Lynne Thornton and ACR
Assistant: Marie-Pierre-Kerbrat

© ACR PocheCouleur
© 1994, ACR Édition Internationale, Courbevoie (Paris)
(Art - Création - Réalisation)
© ADAGP et SPADEM, Paris
© Droits réservés
ISBN 2-86770-084-1
N° d'éditeur : 1085/1
Dépôt légal : octobre 1994

Printed in France by MAME IMPRIMEURS - Tours

WOMEN
AS PORTRAYED IN
ORIENTALIST PAINTING

Lynne Thornton

ACR Edition

PocheCouleur

Lure of the East

*F*rom the 1700s to the 1920s, the racy, highly-coloured stories recounted by Scheherazade in *Alf Laylah wa Laylah,* commonly known in Europe as *Les Mille et Une Nuits,* or *The Arabian Nights,* enjoyed considerable, enduring sucess in the West. Although the tales have a strong spirituality, it was the themes of sexuality, love, violence, humour and guile that left an indelible impression of the Eastern World as being poetical, erotic and violent. In addition, the caliphs, vizirs, odalisques and eunichs who parade through the pages became clichés in the Orientalist repertoire. The first – bowdlerized – translation into French by Antoine Galland captured the public's imagination when it appeared in 1704.

In 1714, the French ambassador Charles de Ferriol published what was to be the most popular and influential of all illustrated Ottoman Empire costume plates, containing engravings by Le Hay after pictures by Jan-Baptiste Vanmour. Like other artists living in Constantinople at the time, Vanmour was commissioned by members of the European community to paint their portraits in Turkish dress. When these diplomats and travellers returned home, many brought back Oriental costumes, as well as fascinating accounts of the fabulous splendours of the Sublime Porte.

The seraglio, palace of the *grand seigneur*, had for centuries aroused interest in the West, all the more so because it was surrounded by secrecy. It was therefore natural that the official visits to Paris, in 1721 and 1742, of two ambassadors dispatched by the sultan to

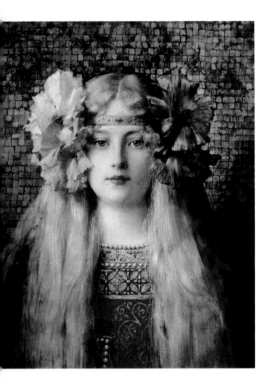

Léon Comerre. *Poppies,* oil on canvas, signed, 23.75 x 19.75 in (60.5 x 50.5 cm). Private collection.

strengthen the opening up of his country to outside contacts excited intense curiosity. In Paris, *turqueries* became all the rage, a vogue that spread to the theatre, opera, interior decoration, fashion, romantic novels and painting. Many French artists, such as François Boucher, Jean-Baptiste Leprince, Nicolas Lancret, Etienne Jeaurat and Jacques de Lajoue, momentarily succumbed to the aristocracy eager to have him paint their portraits *à l'orientale*. Amongst his sitters were the marquise de Sainte Maure, the marquise de Pleumartin, the marquise de Bonnac and the comtesse de Magnac, Although these ladies could hardly be called "harem beauties" – both Madame de Sainte Maure and Madame de Magnac show pronounced double

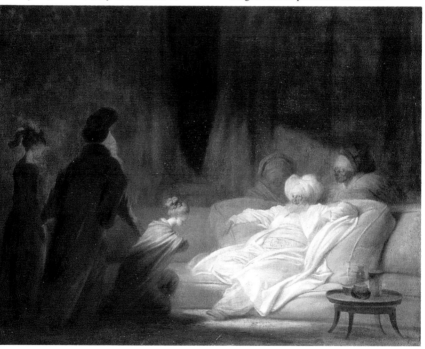

this turcomania, although they themselves had never set foot in the Near East. Jacques Aved, whose portrait of one of the ambassadors, Saïd Mehemet Pasha (Musée National du Château, Versailles), attracted great attention at the 1772 Salon, was particularly in demand by

Jean-Honoré Fragonard. *The Pasha,* oil on canvas, 28.75 x 36.25 in (73 x 92 cm). Private collection.

chins – the clothes at least were authentic. The marquise de Pompadour, installed at Versailles in 1745 as Louis XV's official mistress, owned three pictures by her protégé Carle van Loo showing sultanas doing tapestry, taking coffee and playing a guitar, that may possibly be portraits of the favourite. In these, the costumes and accessories are Oriental, but the architecture is neo-classic. In 1772, Amédée van Loo, Carle's brother, was commissioned to do four pictures intended as cartoons for the Gobelins tapestry manufactory.

Joseph Marie Vien. *Queen Sultana,* oil on paper, 11.75 x 9 in (29.5 x 22.5 cm). Musée du Petit Palais, Paris.

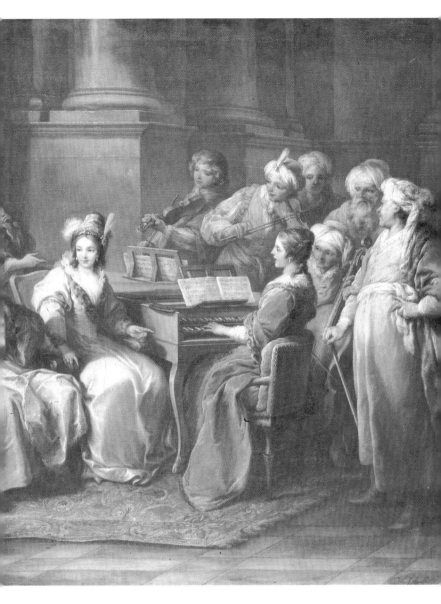

Carle van Loo. *The Grand Turk Giving a Concert to his Mistress,* oil on canvas, signed and dated 1737, 29 x 36.25 in (74 x 92 cm). Wallace Collection, London.

Three of these are owned by the Musée du Louvre, Paris: *The Favourite Sultana with her Female Retainers, served by White and Black Eunuchs, The Sultana issuing Instructions to the Odalisques* (both on loan to the Musée des Beaux-Arts Jules Chéret, Nice) and *Sultana Dressing*.

One outstanding artist who had really travelled in the Near East, Jean-Etienne Liotard, continued to paint

Antoine de Favray. *Madame de Vergennes in Oriental Costume*, oil on canvas, 50.50 x 36.50 in (128 x 93 cm). Private collection.

portraits of Europeans in Turkish dress after his return from Constantinople. Although the exact identity of his sitters is not always certain, these pastels have great charm and are of remarkable simplicity and veracity. The immense success of the comedy entitled *Les Trois Sultanes*, written in 1761 by Charles-Simon Favart, led Liotard to do a miniature (Hermitage, Saint Petersburg) of Madame Favart in the leading role wearing a costume actually made in Constantinople. The play may have also inspired Honoré Fragonard's picture *In the Seraglio*. One of the last portraits of its kind was of Madame de Vergennes, by Antoine de Favray, painted in 1766. In this painting, the model wears a tight-fitting, low-cut caftan. The portrait was done in Constantinople, where Favray had been received by Vergennes, in his capacity as ambassador to the Sublime Porte when the artist arrived in 1762, after spending eighteen years in Malta. Although the vogue for *turqueries* had more or less died out by the 1770s, the East continued to influence fashion. In 1778, Queen Marie Antoinette and her ladies-in-waiting wore dresses called *à la sultane* and a kind of pelisse known as *à la levantine*. During Napoleon's Egyptian campaign, Parisiennes wore a tunic *à la mamelouk,* while in 1802, after the visit of another Turkish ambassador, Esseïd Ali Effendi, there was a short-lived craze for a turban that practically hid the hair, cashmere shawls and dress materials with Oriental motifs. In England, the eighteenth-century mode for Turkish-style dresses and portraits enjoyed a surprisingly long life, fostered no doubt by sophisticated leisure activities such

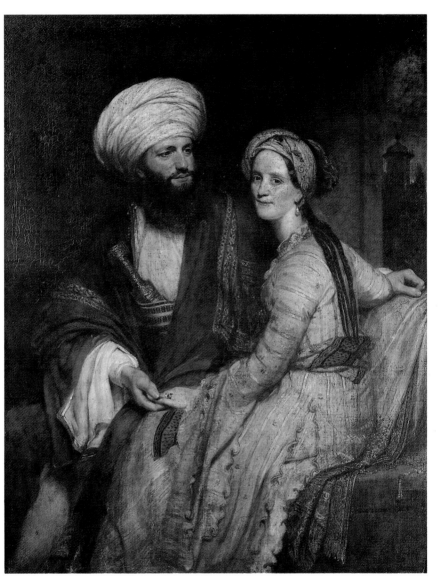

Henry William Pickersgill. *Portrait of James Silk Buckingham and his Wife in Arab Costume of Baghdad of 1816*, oil on canvas, signed, 60 x 48 in (152.5 x 122 cm). Royal Geographical Society, London.

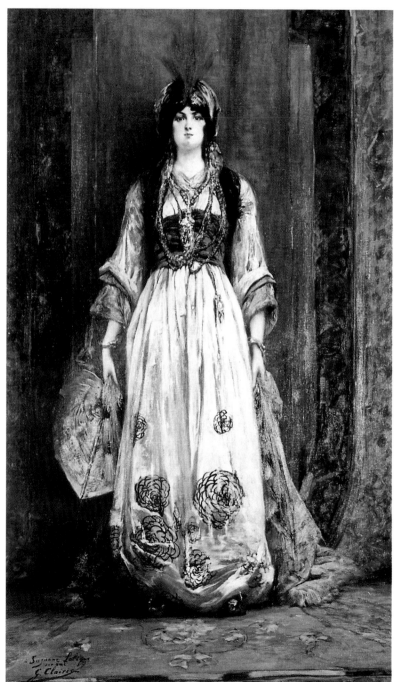

10

as masked balls and masquerades, which were as popular there as in France and Italy. At first, masquerades, introduced into England around 1710, were held by subscription in the King's Theatre, Haymarket, and during the summer in the public pleasure gardens of Vauxhall and Ranelagh. One of the most famous was given by the king of Denmark at the King's Theatre, in 1768, in which the chief personages appeared in Oriental dress; Turkish costume was by far the most popular disguise. At the same time, impressive sums were expended by members of the aristocracy on private masquerades in their own homes. These were commemorated either by prints or by individually-commissioned portraits of the participants in their splendid apparel.

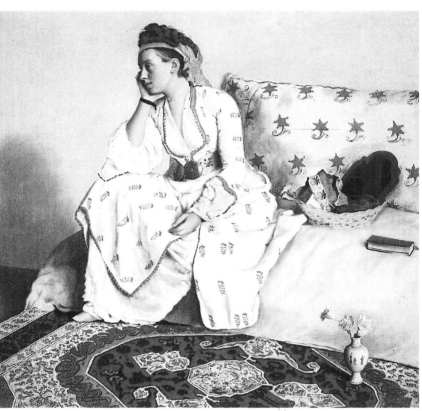

Georges Clairin. *Costume for an Eastern Fête,* oil on canvas, signed, dedicated to Suzanne Lalique, 55 x 31.5 in (140 x 80 cm). Courtesy of the Gallery Keops, Geneva.

Jean-Etienne Liotard. *Presumed Portrait of the Duchess of Coventry,* pastel on parchment laid down on canvas, 36.25 x 29.50 in (100 x 75 cm). Rijksmuseum, Amsterdam.

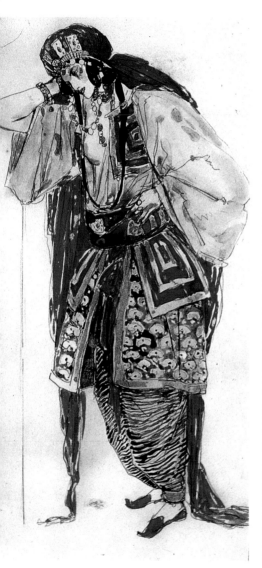

Charles Ricketts. *Costume Design for the Play Judith* (1919), watercolour, signed with monogram, 12.50 x 19 in (31.7 x 48.2 cm). Courtesy of Charles Jerdein, London.

Another notable occasion was the Oriental party held by William Beckford, when Fonthill was transformed into a Turkish palace. Beckford, an immensely rich collector, later wrote a romanesque Oriental tale entitled *Vathek*.

One of the first people to introduce Turkish dress into England was Lady Mary Wortley Montagu, who accompanied her husband to Constantinople on an ambassadorial visit in 1716. During her two-year stay, she found it convenient to dress in the local style, although this was more for reasons of novelty than for ease of travel. A number of portraits were later painted of her in Oriental dress. The best-known, by Jonathan Richardson (The Earl of Harrowby Collection, Sandon Hall), shows her in a gold silk caftan with an ermine-edged gown.

Although there was not the same turcomania as in France, several features of Turkish dress were introduced into English fashion: the tight-fitting caftan, the use of fur, jewelled clasps and turbans, all modified to suit the current taste. On the other hand, the jewelled girdle that thrust out the stomach and emphasised the hips, a feature of authentic Turkish dress, would have been considered ungenteel. So, indeed, would have been loose trousers, and these were never actually worn in England except at masquerades. Following Lady Mary's example, many society women were portrayed dressed in authentic Turkish clothes, fancy dress, or gowns influenced by the East: Philippa Rooper, Lady Sunderlin, by Sir Joshua Reynolds (Department of the Environment, London), Jane, Lady Cottrell-Dormer, also by Reynolds

(T. Cottrell-Dormer Collection, Rousham House) and the American-born wife of General Sir Thomas Gage, by John Singleton Copley (Fine Arts Gallery of San Diego). The ubiquitous Liotard painted Caroline, Countess of Bessborough (The Earl of Bessborough Collection), with whose husband, William Ponsonby, as he was then known, Liotard had travelled to Constantinople in 1738. In a portrait of Mrs. Annetta Pelham, attributed

Willison painted Nancy Parsons (1767-71, Mr. and Mrs. Paul Mellon Collection); the activities of this well-known figure in the *demi-`monde* and her liaisons with various dukes and viscounts kept gossip mongers and scandal columnists busy. The source of Willison's picture, as Ross Watson points out in "Portrait of a Courtesan" (*Apollo,* London, March, 1969), is Liotard's presumed portrait of the Countess of Coventry.

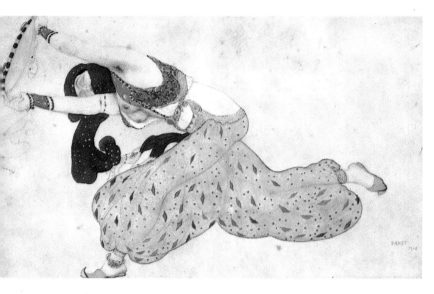

to Joseph Highmore (Museum of Art, University of Kansas), the sitter wears a sumptuous but daringly low-cut caftan of cream brocade. As Aileen Ribeiro has commented in *Turquerie,* this kind of dress, although frowned on by moralists, was highly popular at masquerades, for it gave the wearer an opportunity to display both wealth and her personal charms.

Not all the sitters were of the best tone. The Scottish artist George

Léon Bakst. *Costume Design for an Odalisque in the Ballet Schéhérazade*, pencil, watercolour and gold paint, signed, titled and dated 1910, 8.50 x 13.75 in (21.5 x 35 cm). Private collection.

By the early nineteenth century, the greater number of people travelling to the Near and Middle East meant that too much first-hand information was available for *turqueries* to be acceptable any longer. Moreover, the East no longer exclusively meant Turkey, although European interest in the Ottoman Empire was kept alive by Lord Byron's writings and the Romantics' espousing of the Greek cause in the War of Independence. As hitherto

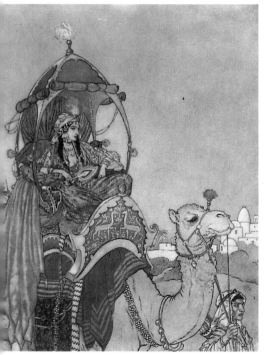

Edmund Dulac. *The Queen of Sheba,* signed and dated '11, *L'Illustration* special Christmas issue, 1911.

mysterious lands revealed themselves, disenchantment sometimes set in. In 1843, Gérard de Nerval sadly commented to Théophile Gautier that there would soon be no place in which he could find a refuge for his dreams and that for a person who had never seen the Orient, a lotus was still a lotus, but for him, it was only a kind of onion. Many travellers and artists continued, however, to invest the East with their own romanticism. The Scottish artist Sir David Wilkie, for instance, refused to paint Europeans during his tour of the Levant in 1840-41 unless he could portray them in Turkish or Arab costume, which most of them would have owned at the time, although their every action and gesture betrayed their origins. What was more, travellers enjoyed posing in Eastern dress on their return home, as is evident in the portrait of James Silk Buckingham and his wife, by Henry William Pickersgill (1825, Royal Geographical Society, London). By the mid-century, travellers no longer pretended to themselves that they could be taken for Orientals and, instead, wore their everyday clothing. Théodore Frère shows Empress Eugénie, who was in Egypt for the opening of the Suez Canal in 1869, riding on a camel in a voluminous dress. This was not only highly inconvenient but also risky, as one of the empress's ladies-in-waiting found out; she fell off her mount, landing skirts in the air, to the unseemly hilarity of the rest of the party.

Since the wearing of Oriental clothes abroad was no longer a common practice, the vogue for Oriental-style portraits gradually waned. In the late 1860s and 1870s, however, the French artist Charles Landelle,

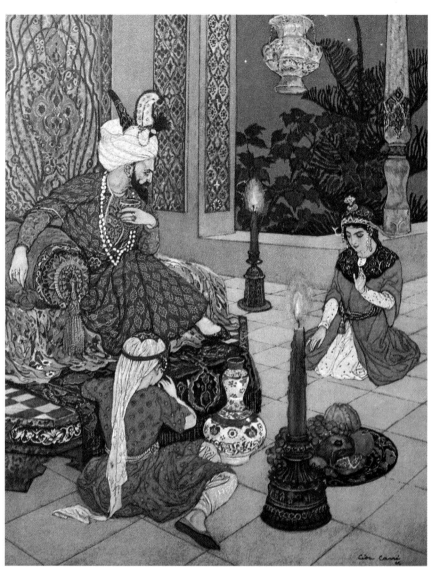

Léon Carré. *The King was not Displeased
to Listen to Scheherazade's Tale*.
Illustration for *Le Livre des Mille et Une
Nuits* (1926).

whose painting *Fellah Woman* had enjoyed great success at the 1866 Salon, was solicited to paint not only replicas of this picture but also portraits of ladies in Egyptian costume. One of these was the marquise de Laubespin, who had travelled to Egypt some years before Landelle did her portrait, shown at the 1876 Salon.

By the end of the nineteenth century, the Europeanisation of clothes and of a way of life that had gained ground in many Near- and Middle Eastern countries took away much of their romantic aura. However, Pierre Loti's fictional autobiographies, with their rose-water exoticism, held his public spellbound, particularly *Les Désenchantées* (1906), a novel about Turkish contemporary harems. This was a sequel to his earlier success, *Aziyadé* (1877), the purportedly true account of his love for a Circassian woman.

It was yet again *Les Mille et Une Nuits* that launched a new rage for the East at the beginning of the twentieth century. The Egyptologist Edward Lane's uninspired and staid English translation of the tales (1838-40) had been followed by that of the Arabist Richard Burton, which was brilliant and lusty. This life work, with its extraordinarily detailed and knowledgeable footnotes, had created a sensation when it appeared, unexpurgated, in 1885. It was, however, the new French translation by Dr. Joseph-Charles Mardrus, published in sixteen volumes from 1899 to 1904, that had the impact of a bombshell on fashion, ballet, the theatre and book illustrations. Mardrus was born in Cairo in 1868. His grandfather, a Catholic from

Mingrelia, had been exiled by the Russians after the Caucasians' long resistance. As a child, Mardrus had been taught all the beliefs, customs and superstitions of the people of old Cairo by the family slave, Aïscha. This unusual education later helped enrich his translations of Arab texts. His version of *Alf Laylah wa Laylah* was illustrated by Léon Carré and, in England, by Edmund Dulac, who took their inspiration from Islamic miniatures and Indian, Tibetan and Japanese art. During the 1920s, François-Louis Schmied, who revolutionised book design, did plates for one of the tales, *Histoire de la Princesse Boudour*, that were strongly marked by an Indo-Persian influence, as well as for other translations by Mardrus. In these illustrations, as in those by Carré and Dulac, the heroines are beautiful, delicate and slender.

Of all the operas, puppet shows, musical reviews, plays and films inspired by *The Arabian Nights,* the most influential was unquestionably the Russian ballet *Schéhérazade*, presented in Paris by Serge Diaghilev in 1910. The exotic splendours of the costumes and decors by Léon Bakst, with their violent colour combinations – emerald and orange, indigo and geranium, vermilion and rose – were a revelation to the audience, who were used to muted pastel tones. Never had a Western public been exposed to anything like these orgiastic colours and frenetic leaps, this exotic sensuality. The plot of this extravaganza is farfetched: harem women, taking advantage of the feigned absence of their master, King Shahriar (who seeks proof of his favourite's

infidelity), indulge in an orgy with the black slaves. This ends, on the king's return, in a bloodbath of vengeance. The ballet, as the writer Charles Spencer has noted in *Léon Bakst,* not only indulged the public's sexual fantasies but satisfied their moral standards by ensuring that the culprits were punished. Bakst's

costumes show the obsessive eroticism of a manic-depressive who found it impossible to establish a relationship with any woman. "It is not merely a question of the daring exposure of full-blown breasts and nipples or thighs and stomachs bulging through tightly-bound sections of the costume," continues

Henry Siddons Mowbray. *The Harem*, oil on canvas, signed, 12.50 x 14.50 in (32 x 37 cm). Private collection.

Spencer. "The eroticism lies in the disposition of the bodies and limbs. Not only is there a masterful rendering of rhythm and movement but the exciting sense of aggressive energy."

In his memoirs, the couturier Paul Poiret resentfully denied that *Schéhérazade* had had any influence on his fashion designs. Although he had indeed been experimenting with Eastern styles and materials several years before, his Oriental fashions were fully launched in 1911, the year after the ballet's première. In June of that year, Poiret gave his famous Persian ball, the *Mille et Deuxième Nuit*. He received his three hundred guests dressed as a sultan, while his "favourite" – Madame Poiret – was seen wearing harem trousers under a short hoop skirt when she was released from a huge gold cage. A monumental buffet, Oriental rugs, tropical birds and monkeys, incense and myrrh burning in braziers, fireworks and bare-breasted black girls completed the magical fête. Poiret's example was soon followed by other Parisians. Oriental-style parties became all the rage in the next few seasons; a painting by Edmond Lapeyre, exhibited at the 1913 Salon de la Société des Artistes Français, shows two women dressing up for a Persian ball assisted by a young black lackey. Women hastened to buy Poiret's satin and silk harem trousers and tunics, topped by turbans adorned with jewel-clasped aigrettes. They were at last free again to walk and run and – in 1912 – dance the latest craze, the tango. When Poiret escorted his models to the Auteuil race track for the first public appearance of the new look,

scandalized and infuriated female onlookers gave chase to the girls, but, since they were wearing the old-style, restricting hobble skirts, they could only scuttle or hop along after them. Chic magazines promoted Poiret's latest fashions through illustrations by George Barbier (who, under the name of Edward W. Larry, had painted scenes from the Ballets Russes), André Edouard Marty, Umberto Brunelleschi, Georges Lepape and Paul Iribe. Not suprisingly for such an accomplished showman, Poiret was soon involved in the theatre. In 1913, he designed the costumes for Jacques Richepin's Oriental-style play entitled *Le Minaret*, assisted by two other illustrators, Zamora and the endlessly imaginative Erté (Romain de Tirtoff). The leading role was played by Ida Rubenstein, a strikingly beautiful Russian who was often painted by Léon Bakst. Every Parisienne who had transformed herself into a Bakst or a Poiret odalisque required a suitable decor in which she could languish and recline on large, plump, tasselled cushions. To cater for or, rather, to promote this demand, Poiret opened a highly successful interior decoration business called Martine. He also launched a line of perfumes called Rosine, whose names included Minaret, Aladdin, Nuit de Chine and Antinéa.

The Colonial Exhibitions held in Marseilles in 1906 and 1922, with their astonishing pavilions in local styles, tribesmen in traditional clothes, dancers and musicians, introduced another wave of exoticism. Posters for "Oriental" creams, face-powders, soaps, perfumes and toothpaste portrayed

corpulent Ouled-Naïl women, Egyptian dancers or harem beauties vaunting these products that were guaranteed to make the user irresistible. Make-up, considered bad form before the First World War, was heavy, with sharply-defined, reddened lips and eyes rimmed with *kohl*, of which Ouled-Naïl and Kohol Idriss were among the best-known makes. Perfumes were offered under the evocative names of possessions, as well as European and American films with exotic settings, continued to nourish the Western world's eternal demand for escapism, it was above all paintings that set people dreaming.

Vallée des Rois, Secret de Sphinx, Ambre de Nubie, Jérusalem or Ghardaïa. Crêpe de Chine and crêpe du Maroc were introduced, adding to the already familiar repertoire of damask, ottoman and Smyrna brocade. Although photographs and postcards of the inhabitants of French and Belgian overseas

Mario Simon. *Odalisque,* gouache, signed and dated 1919, 8 x 10.25 in (20 x 26 cm). Private collection.

Pleasures of life

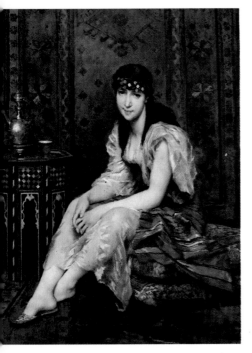

Gustave de Jonghe. *Idleness,* oil on panel, signed, 18.25 x 14.75 in (46 x 37.5 cm). Courtesy of the Gallery Keops, Geneva.

*E*astern women in their quarters were the most popular of all themes in Orientalist painting. Since harems were precisely areas that male strangers could never enter, artists could give full rein to their imagination. Their manner of treating the subject falls more or less into two categories: voluptuous fantasies, on the one hand, and, on the other, domesticity in the European manner transposed and applied to the Eastern world. The harem is probably the best-known of all Eastern institutions, but its full social significance is still often misunderstood. Taken from the Arabic *haram*, the word means "that which is unlawful". Thus, the whole region for a certain distance around Mecca and Medina, owing to the sacredness of these holy places, is *haram*, i.e. certain things allowed elsewhere are not permitted there. In its secular use, the word is used in reference to that portion of a Muslim house, usually the most remote, occupied by the women. It was their *haram* or sanctuary. The Turks softened the work into harem and added to it the termination *lik*. The correct Turkish word for the women's part of the house is

therefore *haremlik*. The abbreviated form, harem, is more correctly applied to the inmates of the *haremlik* but is now generally used to mean the place as well. (N.M. Penzer, *The Harem*). The wife or wives, the children and the female servants would live in this secluded area of conviviality and feminine complicity where their daily occupations were carried on. It was permissible for eunuchs and young

keep out of sight in their quarters. In 1875, having been a guest in a home in Tangiers, Edmond de Amico recorded his recollections as follows: "We heard the sounds of the footsteps and voices of unseen individuals. All around us and above us, invisible life went on, reminding us that we were indeed amidst walls, although actually 'outside' the house; that the beauty and soul of the family had taken refuge in the

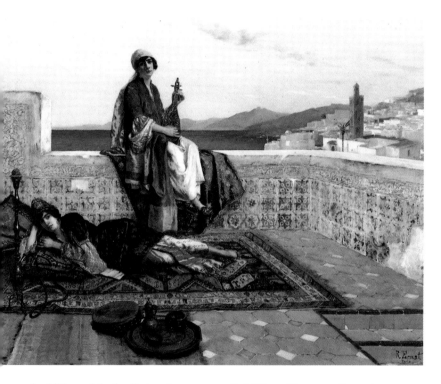

male children of the family to enter, but the code of modesty prohibited any male visitor. Although women were free to mingle with close male relatives, and, if they were veiled, with guests, in the other areas of the house, they generally preferred to

Rudolf Ernst. *Women on a Terrace in Morocco,* oil on panel, signed and inscribed Paris, 28 x 36.25 in (71.2 x 92 cm). Courtesy of the Gallery Keops, Geneva.

dwelling's impenetrable fastnesses; that we ourselves were the spectacle; and that the house remained a mystery." The higher a man's social rank, the more numerous and better-guarded were the women in his household and the more they were the prisoners of taboos and formalities. Affluent Osmanlis retained immensely valuable eunuchs to watch over their harems, although, in Egypt, this practice was already declining under Mehemet (Mohammed) Ali's reign in the early nineteenth century. In *The Blue Nile,* Alan Moorehead points out that "A eunuch was a status symbol, and if a man possessed one, it was a sure sign that there were many women in his household and that therefore he must be wealthy – and wealth attracted Mohammed's tax-gatherers." In fact, of the four wives allowed to each man by the Koran, few but the richest Muslims could afford to keep more than one or two at a time, let alone numerous concubines and servants. Besides, polygamy had its drawbacks. Nadia Tazi, in *Harems,* writes that "The wisest men preferred to enjoy a concubine episodically, or even to repudiate their wives, rather than harbour under the same roof the bitter rivalry of 'competing' wives. And those who did decide to have several legal spouses eluded the troublesome side of harem life by maintaining various separate households in different districts of the city, among which they divided their time." These down-to-earth arrangements were a far cry from the image that many Orientalists liked to convey of harems, that of men surrounded by eager naked women and basking in an atmosphere of heady fragrances, soft music and over-indulgence. The only excessively large harem was the royal one in the Turkish seraglio: at various periods, it accommodated from three hundred to over one thousand women. By and large, harems housed only extended families, including wives, mothers, unmarried daughters and,

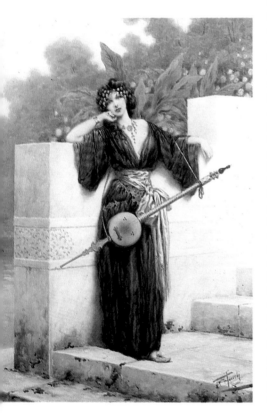

Giuseppe Aureli. *Oriental Beauty,* watercolour, signed and inscribed Roma, 28.50 x 20.75 in (72.5 x 52.5 cm). Courtesy of the Mathaf Gallery, London.

Gaston Saintpierre. *The Oleander Song,* oil on canvas, signed, 33.50 x 21 in (85 x 53 cm). Private collection.

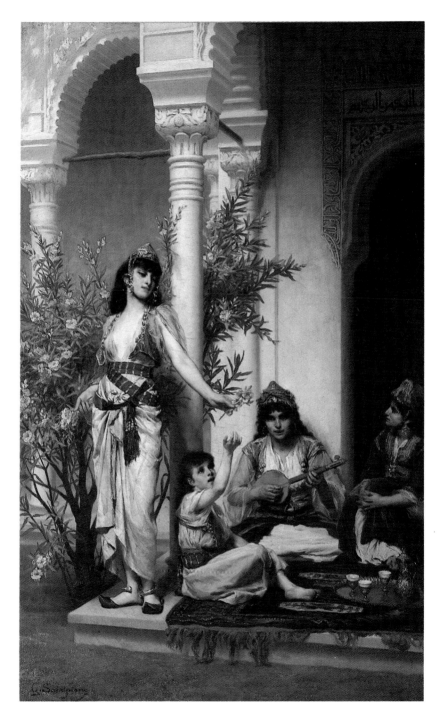

sometimes, more distant female relatives towards whom the head of the household had moral obligations. Victorian artists, who generally reproved the system, rarely, if ever, painted erotic harem scenes. Neither did they show harems in a domestic context, thereby lending them, in the eyes of the public, an air of respectability. There were a few exceptions, such as Frank Dillon, William Purser and John Frederick Lewis. Lewis in particular portrayed Egyptian harems as quietly modest, occupied with everyday activities. Despite the Western world's interest in home life and the family, and the prevalence in nineteenth-century genre paintings of women as loving wives and devoted mothers, scenes of maternity are remarkably rare in Orientalist works. Jan-Baptist Vanmour shows a woman suckling her child, as does Théodore Chassériau in *Moorish Woman Nursing her Infant* (1850, Musée du Louvre, Paris, on loan to the Musée de la Ville de Poitiers). Charles Landelle's *Woman of Bethlehem,* shown at the 1883 Salon is, however, more reminiscent of the traditional representations of the Virgin Mary and the Infant Jesus. There are other tender moments, such as Paul Leroy's *The First-Born: Oriental Scene* (1908 Salon de la Société des Artistes Français). In other paintings of this kind, it is a slave who actually looks after the baby while the mother admires it from a distance, such as in Frederick Goodall's *A New Light in the Harem* (1884, Sudley Art Gallery, Liverpool). Here, the artists were painting scenes familiar to them, since nursemaids as surrogate mothers were always found in prosperous Western households. Writing about Egyptian women in 1878, C.B. Klunzinger commented that "They do not, as the common description of *harem* life leads us to believe, recline the live-long day on a soft divan enjoying the *dolce far niente,* adorned with gold and jewels, smoking and supporting upon the yielding pillow those arms that indolence makes so plump,

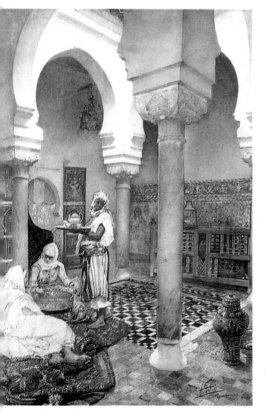

Antonio Fabres y Costa. *Moorish Courtyard,* watercolour, signed and inscribed Roma, 20.75 x 14.75 in (52.5 x 37.5 cm). Courtesy of the Mathaf Gallery, London.

Osman Hamdy Bey. *Girl Arranging Flowers in a Vase,* oil on canvas, signed and dated 1881, 21.75 x 14.75 in (55 x 37 cm). Istanbul Resim ve Heykel Müzei.

Henry d'Estienne. *Young Arab Girl
Carrying the Coffee,* pastel, signed,
25.25 x 17.75 in (64 x 45 cm). Private
collection.

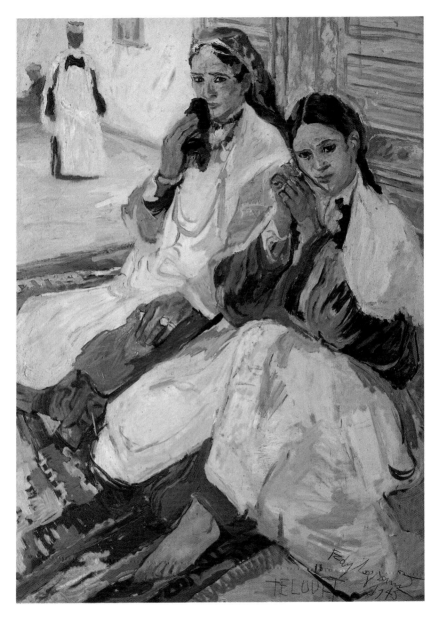

Edouard Edy-Legrand. *The Two Friends,*
oil on panel, signed and dated Telouet
1945, 41 x 29.50 in (104 x 75 cm). Private
collection.

while the eunuchs and female slaves stand before them watching their every sign, and anxious to spare them the slightest movement." Yet this text exactly describes the way many nineteenth-century Orientalists represented harem women. There is one difference: artists showed them as slim – with seductive curves – but definitely slender. They are seen to be drinking tea or coffee, with an occasional bowl of fruit at their side, but never eating a proper meal, nor even nibbling the sweet pastries still so enjoyed today. In many Orientalist works, women loll against cushions doing nothing but idle the hours away, alone or gossiping with companions, day-dreaming or wafting a fan or fly-whisk backwards and forwards. This idleness was strikingly similar to the existence of the leisured society in the Western world at the time. "I do not know how it may affect others," complained Mrs. Sarah Ellis, author

Eugène Giraud. *Interior of an Egyptian Harem*, oil on panel, signed, 20.75 x 36.75 in (52.5 x 93.5 cm). Courtesy of the Mathaf Gallery, London.

Frank Dillon. *Apartment in the Harem of the Sheikh Sâdât, Cairo,* watercolour, 18.75 x 13 in (47.3 x 33 cm). The Victoria and Albert Museum, London.

of books on etiquette in the 1830s and 1840s, "but the number of languid, listless and inert young ladies who now recline upon our sofas murmuring and repining on every claim on their personal exertions is a truly melancholy spectacle." While Lady Anne Blunt found that the Syrian ladies whom she visited in 1878 "had a firm conviction that perfect happiness and dignity consisted in sitting still", the average middle-class girl's life in England was bitterly described by

one sufferer as "that useless, blank, slow-trailing thing." It was, however, socially necessary for a bourgeois woman to be leisured, in order to show that she was estranged from all aspects of vulgar, productive labour. Moreover, wealthy Western households employed a large staff, just as affluent Muslim women were waited on by numerous servants. But whereas the interests of slaves in Islamic countries were protected by law (and they are well- and even

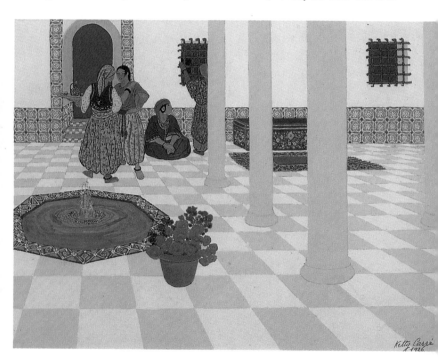

Ketty Carré. *The Servants,* tempera on cardboard, signed and dated 1926, 11.50 x 14.50 in (29 x 37 cm). Private collection.

elegantly-dressed in pictures), many of the lower orders in service in the West lived and worked under ruthlessly severe conditions. Harem women are sometimes seen in contemplative silence, as though oppressed by their cloistered world, as in Henri Evenepoel's 1898 picture of Algerian women and Jules Migonney's *Arab Woman holding a Narghile* (1909, Musée de Brou, Bourg-en-Bresse). However, they rarely have the melancholic and listless look of Eugène Delacroix's *Women of Algiers* (1834, Musée du Louvre, Paris) and the women in Emile Bernard's *In the Harem* (1912) or in Jean Bouchaud's *Red Hands, Algeria,* of 1930. For the most part, harem women were portrayed as gay and frivolous, occupied by a thousand distractions. "In the presence of the husband," noted Edward Lane, "they are usually more or less under restraint and hence they are better pleased when his visits during the day are not very frequent or long; in his absence, they often indulge in noisy merriment."

Tobacco occupied a prominent place in the everyday life of all the social classes, and smoking was common in harems. By the 1870s, cigarettes had come into general use, but narghiles (commonly known in English as hookahs or hubble-bubbles) were also enjoyed. Artists show these still being used in Algeria in the 1910s and 1920s. Théophile Gautier noted that "Nothing is more propitious to the fostering of poetical reveries than relaxing on the cushions of a divan and inhaling, in short intakes, this fragrant smoke, cooled by the water through which it moves, which reaches the smoker after being propelled through red or green

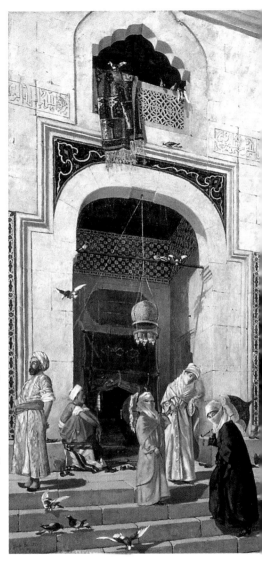

Osman Hamdy Bey. *Door of the Great Mosque, Brusa,* oil on canvas, signed and dated 1881, 47 x 25 in (119.5 x 61 cm). Private collection.

leather tubes that intertwine with his arms, making him somewhat resemble a Cairo snake charmer playing with serpents." The *chibouk* was also popular. The exaggeratedly long stems of these pipes were covered with silk to keep them cool. Gautier further commented that the amber mouthpieces were "varied in their colours and transparencies, polished, turned and hollowed out with loving craftsmanship, and, in the sunlight, they glowed with warm, golden tones that would have made Titian envious and were

enough to fire the most diehard nonsmoker with a craving to indulge in the weed." (*Constantinople,* 1856). These two ways of smoking were also enjoyed by artists and intellectuals in Europe from the 1830s. One example can be seen in Constantin Hansen's picture in the Statens Museum for Kunst, Copenhagen, dated 1837. It shows Danish artists in Rome smoking *chibouks* while they listen to the architect Gottlieb Bindesbøll, in a red *chechia*, recounting the journey he had just made to Greece and

Jean-Léon Gérôme. *Excursion of the Harem,* oil on canvas, signed, 32 x 54 in (81.2 x 137 cm). Private collection.

Turkey. Even the blue caterpillar in Lewis Carroll's *Alice's Adventures in Wonderland* (1865) smokes a narghile ! *Hashish Smoker* (1900, Musée d'Orsay, Paris), by Emile Bernard, was one of many pictures showing the use of narcotics in the East. Western travellers such as Eugène Fromentin and Gérard de Nerval were struck by this custom, and Gautier himself belonged to the *Club des Haschichins,* whose

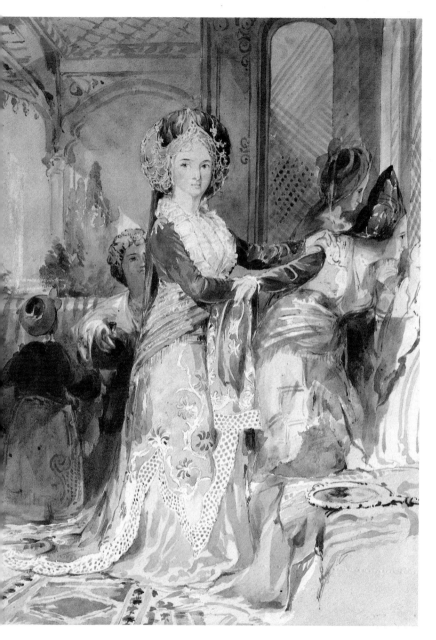

Thomas Allom. *The Favourite Odalisque,* or *The Odalisque* or *Favourite of the Harem, Constantinople,* watercolour, 11.50 x 8.75 in (29.6 x 21.4 cm). The Victoria and Albert Museum, London.

members held their private, secret smoking sessions in the Hôtel Pimodan on the Ile Saint-Louis in Paris. Charles Baudelaire, also a member, later wrote *Les Paradis Artificiels*. Common distractions for harem women in paintings included birds – cockatoos, pink flamingoes, marabous and peacocks. There were monkeys, too, and tame gazelles that trotted around the house or lay at their mistress's feet; dogs inside the home were, on the other hand, prohibited by Islam. Entertainers were occasionally hired, while astrology, palmistry and fortune-telling from coffee-grounds or melted lead were popular, as were story-telling, games of cards or backgammon and the interpretation of dreams. These pastimes were usually painted by the Orientalists in much the same way as genre artists showed the distractions of Western

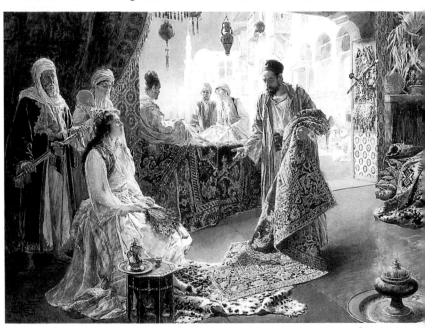

Ettore Simonetti. *The Rug Merchant,* watercolour, signed and inscribed Roma, 22 x 30 in (56 x 76 cm). Courtesy of the Mathaf Gallery, London.

John Frederick Lewis. *In the Bey's Garden, Asia Minor,* oil on canvas, signed and dated 1865, 39 x 27 in (106.6 x 68.6 cm). The Harris Museum and Art Gallery, Preston.

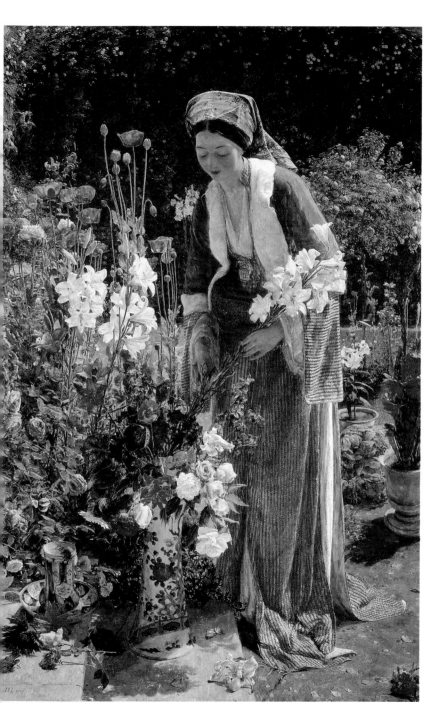

society women in their drawing-rooms. In Eastern houses, there was the ritual preparation of tea, sherbets to be made from violets, roses, oranges and apricots, special dishes to tempt the palate, and coffee, flavoured with mastic, cloves, amber or rose petals, to be brewed. Few women could read or write, but in the harems of certain cultivated and travelled men, they not only learned foreign languages, but had access to books or periodicals from Europe. Mohammad Shah's uncle, Prince Malek Qâssem Mirza, for instance, spoke seven languages and was a regular subscriber to the *Revue des Deux Mondes* and *Charivari*, the most Parisian of French magazines in the 1830s and 1840s. Nearly all women in towns did embroidery and sewing, light tasks that were far removed from the back-breaking labour that country women faced as

Jan-Baptist Huysmans. *The Fortune-Teller,* oil on canvas, signed and dated 1875, 19.75 x 29 in (50 x 73.5 cm). Private collection.

part of their everyday lives. The Orientalists often showed harem women or servants playing musical instruments, usually mandolins, either for their own entertainment or for that of guests. In the harem of the Turkish seraglio, a troupe of dancers and pantomimists was selected and trained, as well as an orchestra. It was said that during the reign of Sultan Selim III (1789-1807), a French dancing-master and a number of male musicians even had permission to enter some outer building of the harem; there, in the presence of several eunuchs, they gave lessons to the girls who had been chosen to act in the next performance. These were novices who had not yet embraced the Muslim religion, as exhibitions of this nature were generally frowned upon.

Etorre Simonetti. *The Fortune-Teller,* watercolour, signed and inscribed Roma, 21.25 x 30 in (54 x 76.5 cm). Private collection.

Filippo Bartolini. *Women in a Courtyard, Tlemcen,* watercolour, signed and dated Tlemcen 1881, 20.5 x 13.75 in (52 x 35 cm). Courtesy of the Mathaf Gallery, London.

Achille Boschi. *The Harem,* oil on canvas, 21.50 x 31.50 in (55 x 80 cm). Courtesy of the Mathaf Gallery, London.

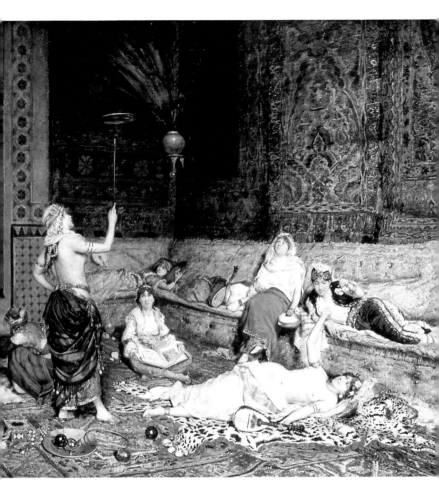

Professional dancers such as the Egyptian *ghazeeyehs* would not have been allowed into a respectable harem.

Despite the extraordinary variety and richness of traditional tribal dances in North Africa, these were largely ignored by artists, with the exception of early twentieth-century painters in Morocco and Algeria such as Edouard Edy-Legrand, Jacques Majorelle, José Cruz-Herrera, Alfred Dabat, André Suréda and Adolphe Gumery. Paul-Elie Dubois, who made an historical expedition to the Hoggar in 1928, did a series of pictures of Touareg women playing *amzads,* or violins. Well-born women in this matriarchal society were often highly-considered poets and musicians and it was customary for tribesmen to ride over long distances to listen to them.

Many Westerners imagined that there was no alternative for Muslim women other than to remain

secluded in their quarters. However, the latticed moucharabies set into the projecting gazebos of houses in Constantinople and Cairo allowed women to observe all that happened below, while themselves remaining unseen. In addition, gardens, roof terraces and patios gave women a chance both to enjoy themselves outside the house and to take the air. These areas were still considered *haram*, sanctuaries in which women were safe from observation and which acted as a barrier between them and the outside world. Alberto Pasini and Osman Hamdy Bey both painted Turkish women in the enclosed gardens of *yalis*, or country homes. In one of Pasini's pictures, *Harem in the Countryside on the Bosphorus*, a group relax on a carpet by a pool while one of their companions peers at the water through a latticed fence. A similar scene is found in *Evening Reverie at the Golden Horn* (1912), by Rudolf

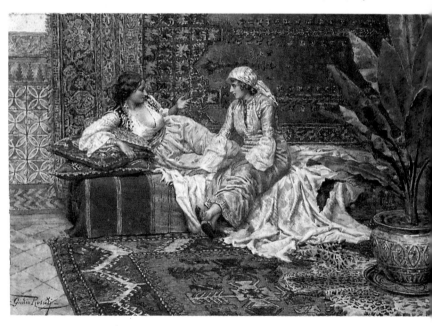

Giulio Rosati. *Gossiping,* watercolour, signed, 10 x 14.50 in (25.5 x 37 cm). Courtesy of the Mathaf Gallery, London.

Ernst. Camille Corot painted a *Young Algerian Woman lying on the Grass* (1871-73, Rijksmuseum, Amsterdam), and Narcisse Diaz de la Peña frequently depicted Turkish families relaxing in gardens; a typical example is in the Museum of Fine Arts, Boston. John Frederick Lewis shows richly-dressed women picking flowers in *The Bouquet* (1857, Dunedin Art Gallery, New Zealand), *Lilium Auratum* (1871, City of Birmingham Museum and Art Gallery) and *In the Bey's Garden, Asia Minor* (1865, Harris Museum and Art Gallery, Preston). Roof terraces were favourite places in which to linger, take a siesta, feel the refreshing breeze or entertain friends. These flat roofs also allowed women to go undetected from one house to another. It is clear from a number of paintings how much women enjoyed this open-air freedom, for example, in Léon Cauvy's *Terraces in Algiers* (1911, Musée National des Beaux-Arts, Algiers, on loan to the Musée de Cirta, Constantine) as well as in works by Eugène Giraud, Rudolf Ernst, Benjamin-Constant, Fabio Fabbi and Jean-François Raffaëlli. An Algerian in a picture by Alfred Chataud prepares couscous on her roof; Suzanne Drouet-Reveillaud shows young Moroccans carding wool, and Marie Martin-Gordault, women eagerly watching the preparations for a feast in *On the Terraces, in Tunis* (1913). In Jules Muenier's *Women of Algiers on the Terraces* (1888), a servant fans the glowing embers of a brazier before cooking fish.
Excursions, promenades and visits to other harems were particularly welcomed by the more secluded women of the richer households. "The highest orders are the more closely guarded," noted Mrs. Poole in 1840, "yet as this very circumstance is a mark of distinction, the women congratulate each other on this subject." Since female servants would usually accompany their mistresses, adding to the line of veiled figures, foreigners would mistakenly believe the number of women in a harem to be greater than it really was. This act

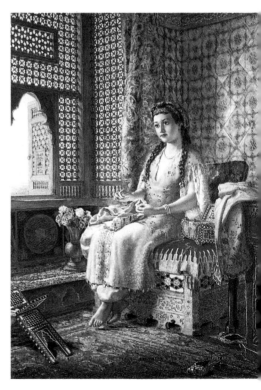

Dorofield Hardy. *Dreaming,* watercolour, signed and dated 1882, 24 x 17.5 in (61 x 44.5 cm). Courtesy of the Mathaf Gallery, London.

of veiling the face was not a religious obligation; the Koran enjoins believers to cover their ornaments and breasts from the view of any man other than their husbands and close male relatives, to avoid inciting his desire. Gradually, veiling became a social institution, the sign of modesty and virtue and the mark of the transition from childhood to womanhood. In fact, veiling was practised above all by women living in cities and large towns, where encounters with male outsiders were unavoidable. The filmy *yashmaks* worn by women of high rank in Constantinople hardly hid their faces, although their dresses were covered by *feraces*, or cloaks. The folds of the shroud-like *haïk* worn by North African women were used to great effect by early twentieth-century artists such as Bernard Boutet de Monvel, Marcelle Ackein, Lucien Simon, Maurice Marinot, Léon Cauvy and Lucien Lévy-Dhurmer. Nomads and country women, who had to work hard for their living, left their faces bare, as a veil would have been in their way. However, they would often catch the edge of their cloak or *haïk* in their teeth or hand at the approach of a stranger. Some women were never veiled, such as the Touareg of the Hoggar. This people was, moreover,

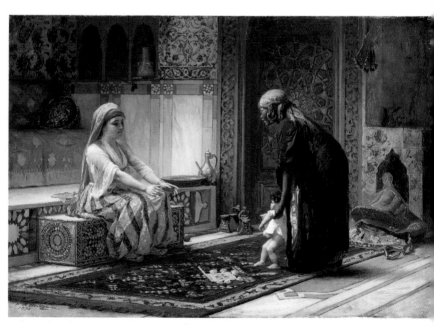

Frederick Arthur Bridgman. *The First Steps,* oil on canvas, signed and dated 1878, 15.50 x 21.75 in (39.4 x 55.2 cm). Private collection.

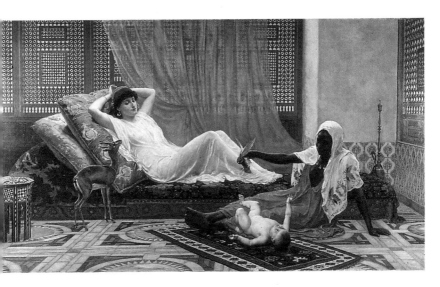

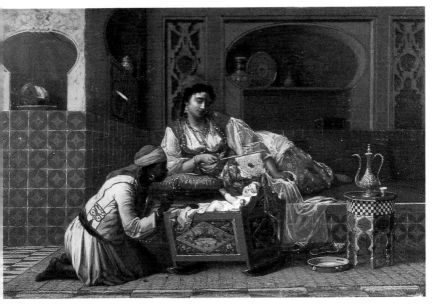

Frederick Goodall. *A New Light in the Harem,* oil on canvas, 48 x 84 in (122 x 213.5 cm). Sudley Art Gallery, Liverpool.

Jan-Baptist Huysmans. *Tending Baby,* oil on panel, signed, 15.75 x 35.75 in (40 x 60 cm). Archives Berko Fine Paintings, Knokke-Heist.

exceptional in that it was the men, not the women, who were always veiled, their indigo *lithams* leaving only slits for their eyes.

Women in souks or bazaars were a popular subject with the Orientalists. The Italians working in Rome – Ettore and Amedeo Simonetti, Giuseppe Ballesio, Ulpiano Cacciarelli and Fabio Fabbi – were fond of painting well-dressed women, only lightly veiled, if at all, inspecting vases or rugs spread out by merchants. In *Le Tour du Monde*, M. Lortet describes how Syrian women in the 1880s would spend hours in the boutiques, looking, touching, squeezing, discussing, bargaining. They would turn the shop upside down, persuade the owner to pull out all his carpets and fabrics... and then decide not to buy anything ! In many countries, there were public entertainers to watch in the streets, such as acrobats, jugglers, musicians, snake-charmers

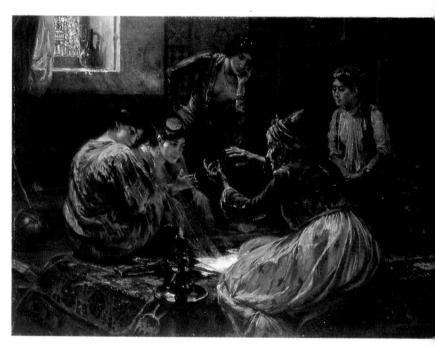

Ferencz Franz Eisenhut. *The Story Teller,* oil on canvas, signed and dated München 1903, 33.50 x 45.25 in (85 x 115 cm). Courtesy of the Galerie Nataf, Paris.

Clemente Pujol de Guastavino. *Musician,* oil on panel, signed, 28.50 x 20.50 in (72.4 x 52 cm). Courtesy of the Mathaf Gallery, London.

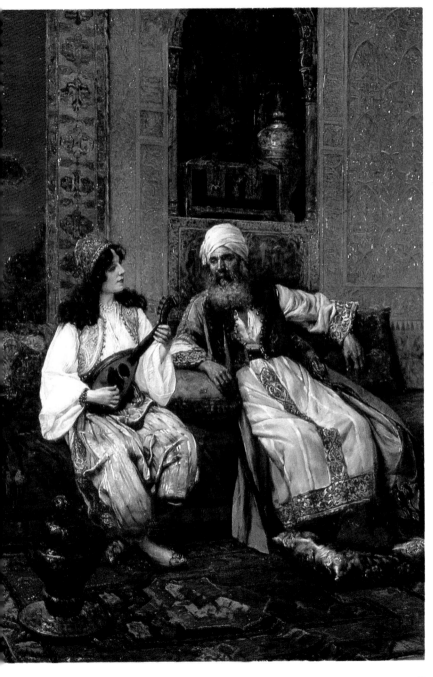

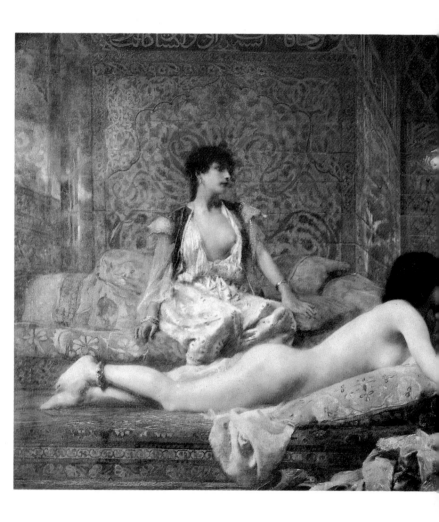

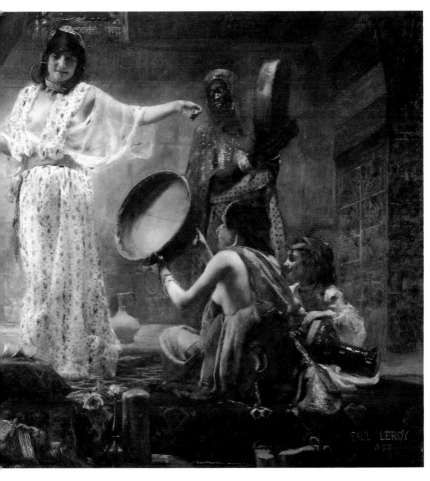

Paul Leroy. *Arab Dance,* oil on canvas,
signed and dated 1888, 78.75 x 157.50 in
(200 x 400 cm). Private collection.

Benjamin-Constant. *Evening on the Terraces, Morocco,* oil on canvas, signed and dated 1879, 48.50 x 78.25 in (123.1 x 98.5 cm). Montreal Museum of Fine Arts.

Gustavo Simoni. *Resting on the Terrace,* watercolour, signed and dated '90, 39.25 x 19.75 in (100 x 50 cm). Private collection.

and male dancers. Another familiar sight was public scribes, who provided an essential service. In Sir David Wilkie's picture *The Turkish Letter Writer* (1840, Aberdeen Art Gallery and Museums), two women listen to the scribe reading back the letter they have just dictated to him. In Constantinople, one of the great pleasures was outings in caïques, slender, pointed rowing boats, on the waters of the Golden Horn. The particularly splendid gilded boats belonging to the seraglio were painted by Félix Ziem, in *Constantinople, the Sultana's Caïque* (Petit Palais, Paris) and Amadeo Preziosi, in *View of the Sultan's Barges in front of the Nusretiye Camii* (circa 1843-50, The Victoria and Albert Museum, London). More ordinary caïques were used to transport fruit and vegetables, but those kept by the elite for excursions were magnificent. "Silken carpets trailed in their wake; often fine gilt chains

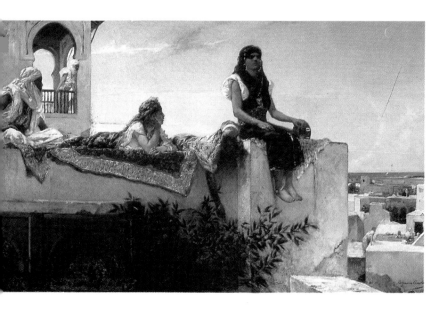

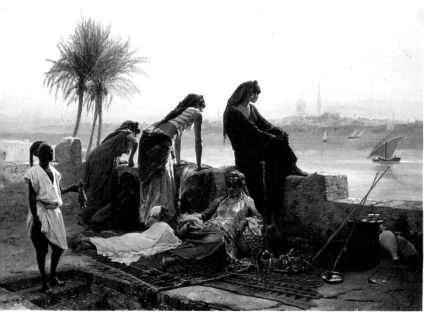

Eugène Giraud. *Terrace on the Banks of
the Nile*, oil on canvas, signed and dated
1878, 55.50 x 77.50 in (141 x 197 cm).
Private collection.

to which golden fish were attached bobbed and frisked on the froth of water around them," writes Lesley Blanch. Families would go by caïque to the favourite resorts outside the city, the Sweet Waters of Asia and the Sweet Waters of Europe. These two meadows on the banks of streams were dotted with kiosks, and there people could enjoy music, pantomimes, acrobats, dances and horse races. One of the earliest paintings of these entertainments is a highly-detailed picture by Johann Michael Wittmer in the Bayerische Staatsgemäldesammlungen, Munich. The German artist travelled to Greece and Asia Minor in 1833 with Maximilian, crown prince of Bavaria and brother of Otho, king of Greece. Another form of transport, less elegant and certainly less

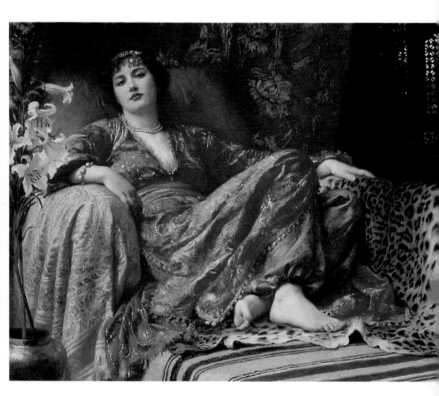

Sir Frank Dicksee. *Leila,* oil on canvas, signed and dated 1892, 40 x 50 in (101.6 x 127 cm). Courtesy of The Fine Art Society, London.

Marie-Antoinette Izart. *The Cup of Coffee,* oil on canvas, signed and dated 1901, 67 x 47.25 in (170 x 120 cm). Private collection.

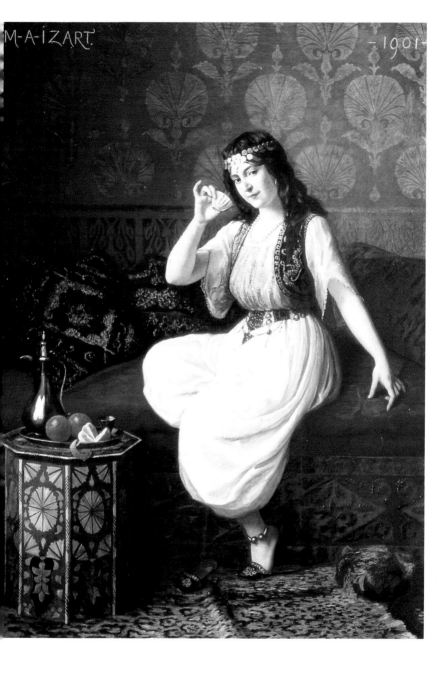

51

comfortable, was *arabas*, carriages drawn by richly caparisoned oxen, in which veiled harems would sway and rock over the rough roads. In North Africa, other pleasures awaited countrywomen, such as bathing in rivers, pools or *wadis*. In an 1866 painting, Eugène Fromentin shows Algerians, modestly covered by their tunics, paddling in a clearing at sunset. From the 1890s to the 1920s, Etienne Dinet frequently painted Ouled-Naïl women happily splashing around in the water. Although they wear turbans and jewellery, their tawny, rounded bodies are naked. Both Dinet and Mohammed Racim portrayed women standing in cascades, the water pouring over their shoulders. As Muslims, these artists would have been aware that cascades, or

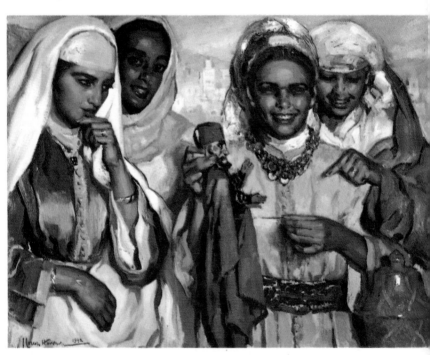

José Cruz-Herrera. *The Puppet,* oil on canvas, signed and dated 1942, 28.75 x 36.25 in (73 x 92 cm). Private collection.

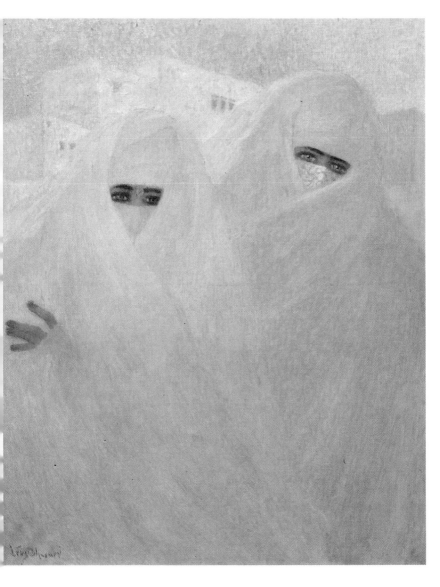

Lucien Lévy-Dhurmer. *Evening Outing* or
Women on an Outing, Morocco, oil on
canvas, signed, 32 x 25.75 in (81 x 65 cm).
A.G. collection.

cherchârs, were often venerated and that ex-votos would be placed around them. In Marius de Buzon's *Bathing at Twilight*, dated 1934, typical of the artist's pastoral scenes in Kabylia, two women stand in a pool up to their knees, as a herd of goats approach to drink at the water's edge. There were, of course, many bathing spots enjoyed by the European population in Algeria. An unusual picture by Georges Debat, *Gorges of Rummel* (circa 1906, Musée de Cirta, Constantine), shows European women in the long dresses and large hats of the period paying to enter one of the two thermal swimming pools at the foot of the promontory on which stands the town of Constantine.

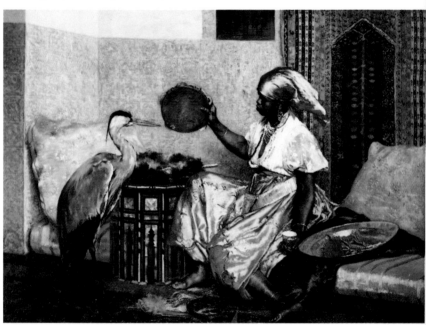

Ferdinand Roybet. *Keeping the Marabou Amused,* oil on canvas, signed, 35 x 53 in (89 x 129 cm). Courtesy of the Galerie Antinéa, Paris.

Ange Tissier. *An Algerian and her Slave,* oil on canvas, signed and dated 1860, 51.25 x 38.25 in (130 x 97 cm). Musée National des Arts d'Afrique et d'Océanie, Paris.

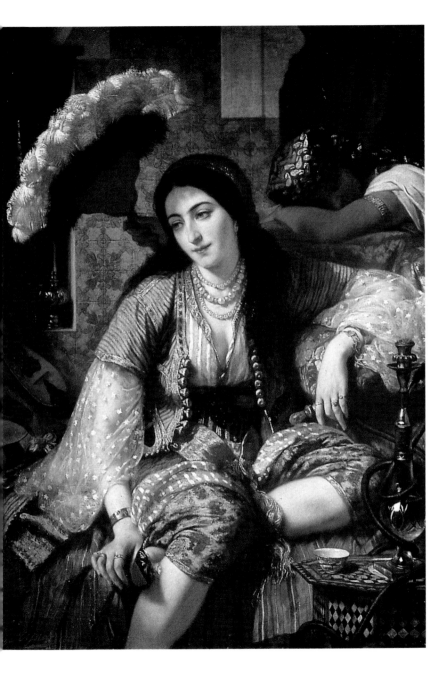

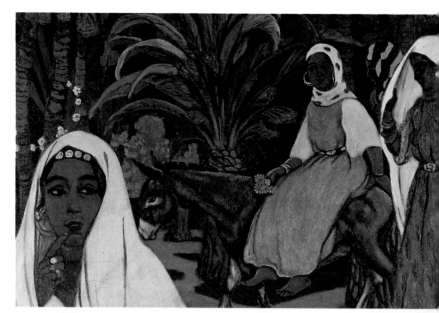

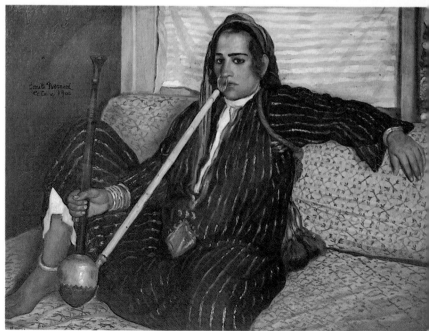

André Suréda. *In the Palm-grove,* oil on canvas, signed, 28.75 x 36 in (73 x 92.5 cm) (detail). Félix Marcilhac collection, Paris.

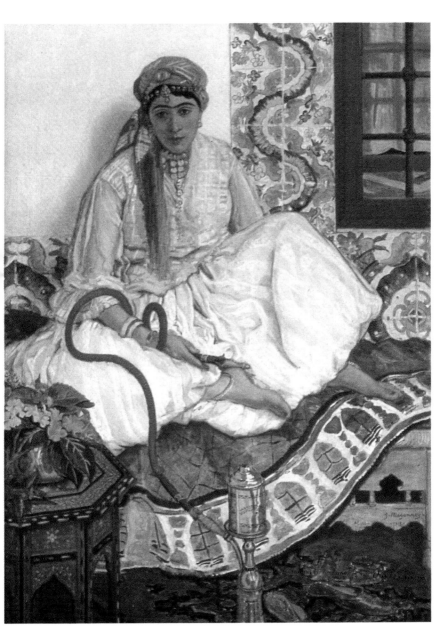

Emile Bernard. *Hashish Smoker*, oil on
canvas, signed and dated Le Caire 1900,
33.50 x 45 in (85 x 114 cm). Musée
d'Orsay, Paris.

Jules Migonney. *Arab Woman Holding a
Narghile,* oil on canvas, signed and dated
Alger 1909, 63 x 49.25 in (160 x 125 cm).
Musée de Brou, Bourg-en-Bresse.

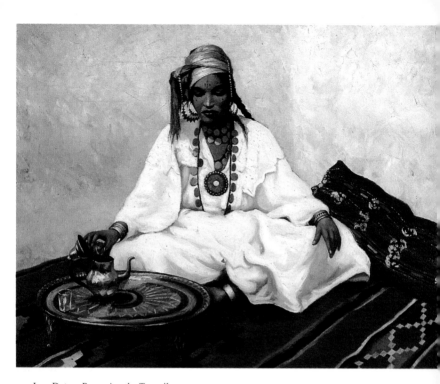

Jean Dutey. *Preparing the Tea,* oil on
canvas, signed, 25.75 x 32 in (65 x 81 cm).
Musée National des Arts d'Afrique et
d'Océanie, Paris.

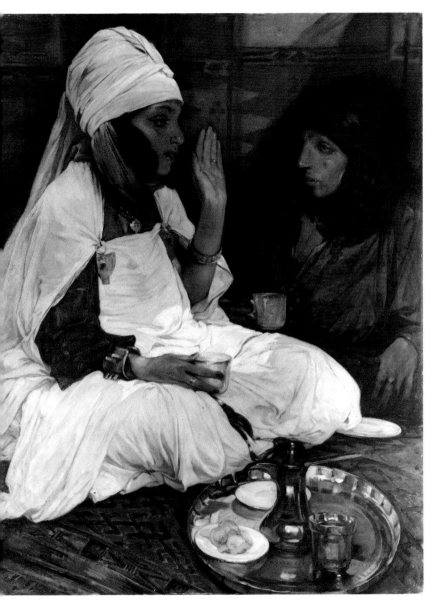

Jules van Biesbroeck. *The Discussion,* oil
on canvas, signed, 31.50 x 23.50 in
(80 x 60 cm). Private collection.

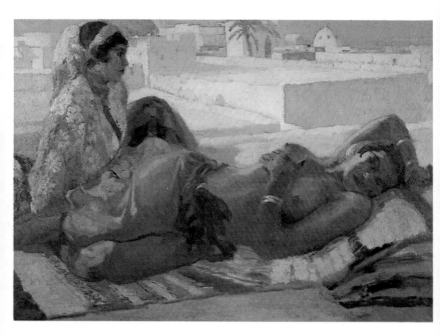

Elie Anatole Pavil. *On the Terrace,* oil
on canvas, signed, 25.50 x 36.25 in
(65 x 92 cm). Private collection.

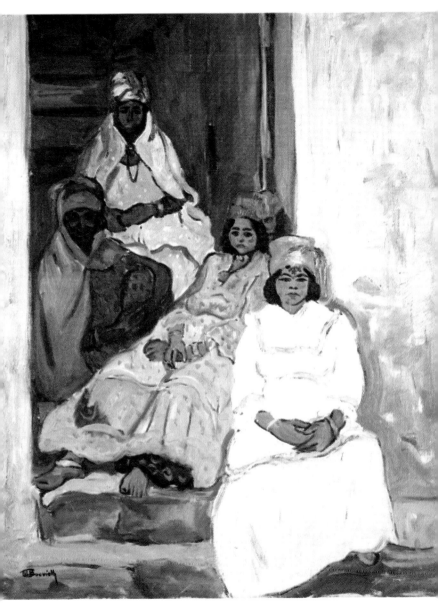

Maurice Bouviolle. *The Blue Staircase*,
oil on canvas, signed, 24 x 19.75 in
(61 x 50 cm). Private collection.

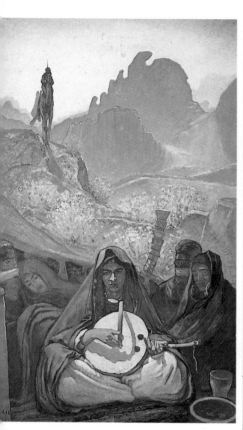

Paul-Elie Dubois. *The Amzad Player,*
oil on canvas, signed 114.25 x 71 in
(290 x 180 cm). Musée National des Arts
d'Afrique et d'Océanie, Paris.

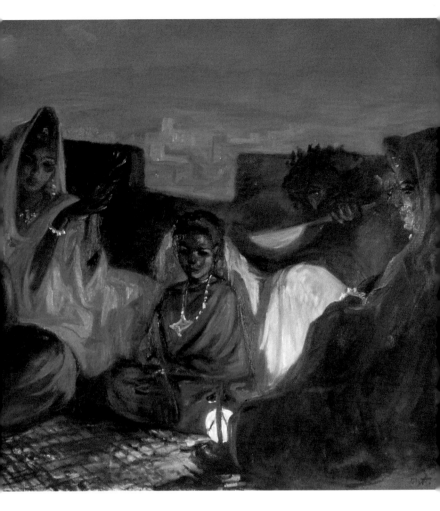

Myrto Debard. *Nocturnal Dance,* oil
on canvas, signed, 39.50 x 59 in
(100 x 150 cm). Courtesy of the Galerie
Antinéa, Paris.

Beauty

*T*o cleanse and purify oneself is a religious obligation in Muslim countries for both men and women, from the highest to the lowest. It is not surprising, therefore, that the institution of the public bath, or hammam, developed rapidly and systematically at the same time as the expansion of Islam. While the Roman thermae were concentrated

Jules van Biesbroeck. *Entering the Hammam,* oil on panel, 33.50 x 45.50 in (85.3 x 115.7 cm). Private collection.

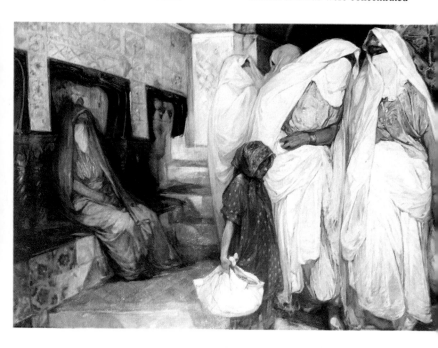

only in the great cities, hammams were more widespread, and nearly every small town or village boasted one or more. Although comparatively few Orientalists painted baths, they were, however, fully described by European travellers, except for the seraglio

John Singer Sargent. *Ambergris Smoke,* oil on canvas, signed and dated Tanger 1880, 54.75 x 35.75 in (139.1 x 90.7 cm). Sterling and Francine Clark Art Institute, Williamstown.

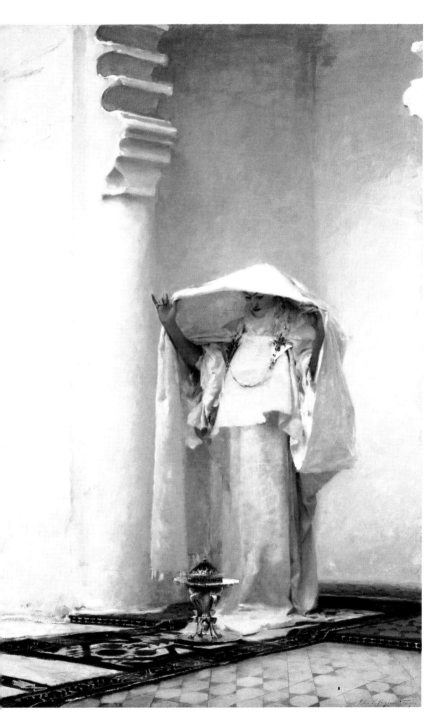

baths, which were forbidden to all outsiders. However, N.M. Penzer, in *The Harem,* claims that the number of baths in the seraglio was always considerable. Apart from the sultan and the *valide* (queen mother), each of the four *kadins,* or favourites, had baths in her own quarters, while others were shared by lower-ranking members of the harem. The number must have totalled some thirty or more, heated by water introduced under the floor, in the Pompeiian system, or else distributed to the various wall fountains on different sides of the room.

In seventeenth-century Constantinople, there were some three hundred public baths and over four thousand privates ones, although their numbers diminished over the years. When the early nineteenth-century sultans began to tire of the seraglio as their royal residence, they selected the most beautiful sites for palaces. These had large and costly hammams, no longer in three domed rooms as was

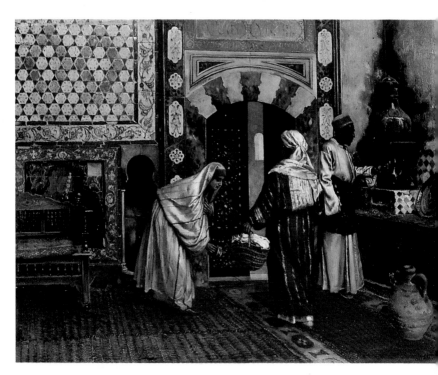

Rudolf Ernst. *The Hammam,* oil on panel, signed, 21.15 x 24 in (48.5 x 60.7 cm). Courtesy of Alain Lesieutre, Paris.

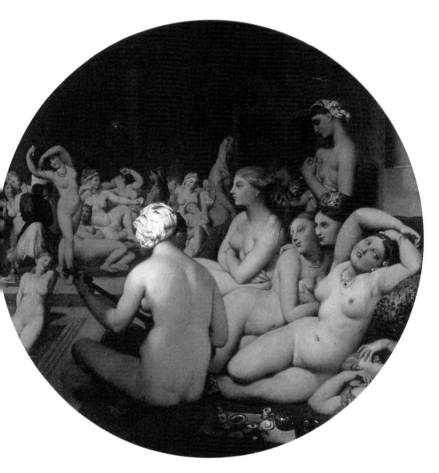

Jean-Auguste-Dominique Ingres. *Turkish Bath,* oil on canvas laid down on panel, signed, dated MDCCCLXII and inscribed Aetatis LXXXII, diameter 39.50 in (100 cm). Musée du Louvre, Paris.

traditional but in a single marble-decorated room whose flat walls were hung with large mirrors. One of the more reliable eye-witnesses of a woman's day in an Adrianople public bath was Lady Mary Wortley Montagu. "The first sofas were covered with cushions and rich carpets on which sat the ladies; and on the second, their slaves behind them, but without any distinction of rank by their dress, all being in the state of nature, that is, in plain English, stark naked, without any beauty or defect concealed. Yet there was not the least wanton smile or immodest gesture amongst them." She was pressed by the ladies to undress and join them. "I was at last forced to open my shirt and shew them my stays, which satisfied them very well, for I saw they believed that I was locked up in that machine, and that it was not in my power to open it, which contrivance they attributed of my husband" (1817).

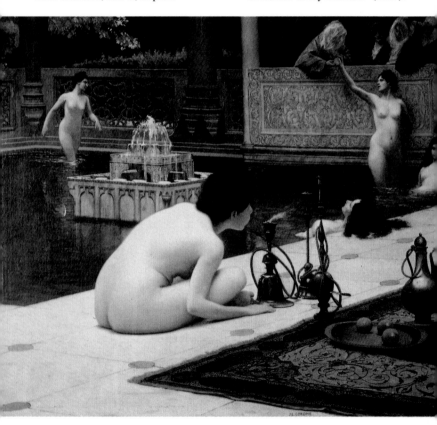

Jean-Léon Gérôme. *The Narghile Lighter*, oil on canvas, signed, 21.50 x 26 in (54.6 x 66 cm). Courtesy of the Gallery Keops, Geneva.

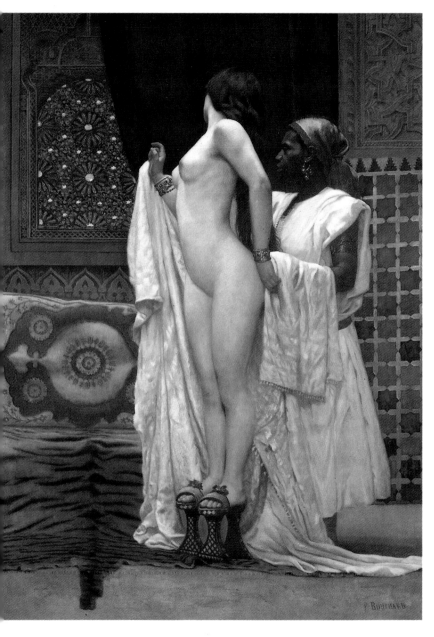

Paul-Louis Bouchard. *After the Bath*,
oil on canvas, signed, 86.75 x 63 in
(220 x 160 cm). Private collection.

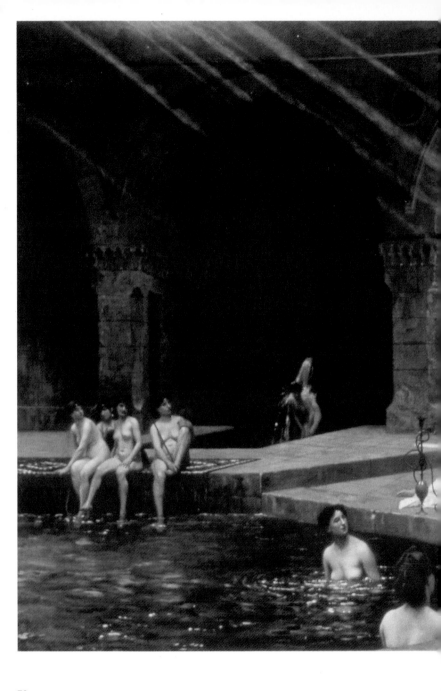

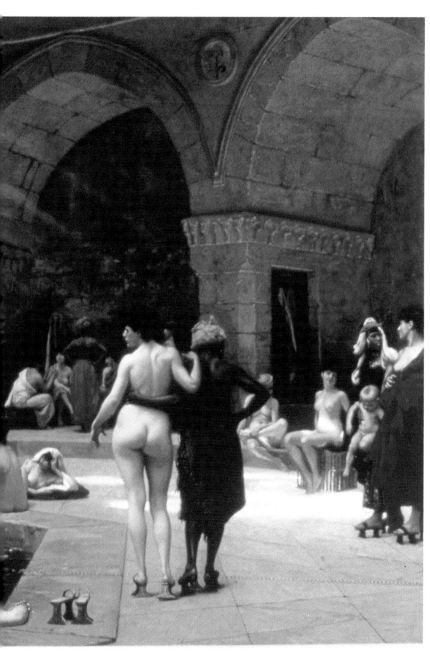

Jean-Léon Gérôme. *The Great Bath at Brusa*, oil on canvas, signed, 27.50 x 38 in (70 x 96.5 cm). Private collection.

71

Another Englishwoman, Mrs. Harvey, was more venturesome. She recounts that, wrapped in a white bathing gown and perched on tall pattens on which she slithered all over the slippery marble floor, she allowed herself to be led into the steam room. There, "In an instant I felt as a shrimp, if he feels at all, must feel in boiling water – I was boiled. I looked at my companion; her face was a gorgeous scarlet. In our best Turkish and in faint and imploring accents, we gasped 'Take us away!' All in vain. We had come to be boiled and rubbed and boiled and rubbed we must be" (1871). One of the earliest pictures of a woman in a hammam is Jean-Etienne Liotard's *Frankish Woman in Turkish Dress and her Servant* (circa 1742-43). The tall wooden pattens on which she stands were considered more elegant than the lower ones worn by the young servant girl. Pattens, probably introduced from Venice, were useful in hammams for protecting the feet from the heated marble floor and for preventing slipping on the wet surface. The more costly ones were of rosewood, ebony or sandalwood studded with silver nails. In the royal harem, they were even more luxurious, with inlaid mother-of-pearl and tortoiseshell. Another chaste and modest painting is Ingres's *Valpinçon Bather* (1808, Musée du Louvre, Paris), in which the seated naked woman is seen in a harmonious, silent and private world.

Ingres's long series of bathers culminated in what is probably the best known of all hammam scenes, *Turkish Bath* (1862, Musée du Louvre, Paris). Here, an extraordinary profusion of nudes is shown reclining or sitting so close to each other that their thighs touch. Two women are tenderly intertwined, while another throws herself back with an abandoned air. While preparing this picture, the artist read and copied out the French translation of Lady Mary's letters, but although, as we have seen, she emphasises the fact that there was no impropriety amongst the large crowd of bathers, Ingres seems to have ignored this comment. Kenneth Clark, writing about nudes in art, reckoned that the 1860s could be considered the high-water mark of nineteenth-century prudery and that perhaps only Ingres, with his seat in the Academy, his frock-coat and his orthodox opinions, could have persuaded public opinion to accept so open an evocation of eroticism. While Ingres' *Turkish Bath* combines sapphism and voyeurism, other bath scenes, although less blatantly sexual, remain suggestive.

In French eighteenth-century engravings, usually derived from paintings done for a private market, women are glimpsed in moments of intimacy, being attended to by their maids who pay homage to their mistress's beauty while seeming accidentally to reveal their charms.

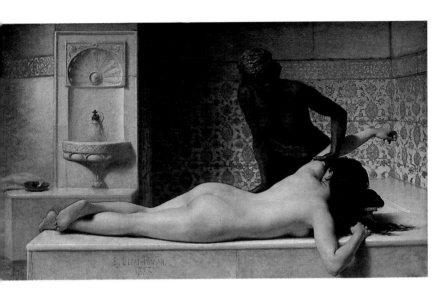

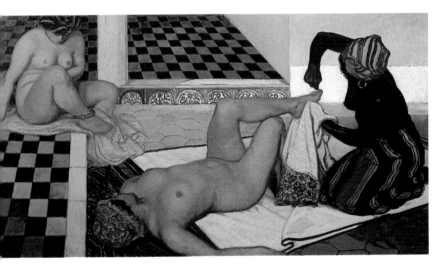

Edouard Debat-Ponsan. *Massage, Hammam Scene,* oil on canvas, signed and dated 1883, 50 x 82.75 in (127 x 210 cm). Musée des Augustins, Toulouse.

Jules Migonney. *The Moorish Bath*, oil on canvas, signed and dated 1911, 41 x 74 in (104 x 188 cm). Musée de Brou, Bourg-en-Bresse.

The same ploy was used by a number of Orientalists.

Mademoiselle de Clermont, daughter of the Prince de Condé, in Jean-Marc Nattier's painting (1773, Wallace Collection, London), with adoring turbanned black servants at her side, exposes her thighs as a maid dries her foot. In Frédéric Bazille's *Emerging from the Bath* (1870, Musée Fabre, Montpellier), a naked woman is helped by a kneeling black maid, while another maid, with an admiring look, holds out a robe. A more authentic Eastern background is seen in a series of paintings by Théodore Chassériau dating from the 1840s and 1850s, although the French models, naked except for wrappings which slip down from their hips, remind one of classical pictures of Venus, Andromeda or Diane. A typical work by this artist is *Moorish Woman emerging from the Bath* (1854, Musée des Beaux-Arts, Strasbourg); the bather is attended to by Algerian servants, one of whom gazes up at her beautiful face and naked breasts. By the late nineteenth century, the number of maids was generally reduced to one. In many pictures, she is seen drying her naked mistress while at the same time turning her towards the spectator, as in Paul-Louis Bouchard's *After the Bath* (1894). She is fully dressed; indeed, black women were never shown naked. On the other hand, in Léon Comerre's *The Bath at the Alhambra*, the generous breasts of the seated black servant are as much a focus of interest as the white woman's firm buttocks. Much has been written recently about the shock of contrasting skin colours, particularly in such paintings as Jean-Léon Gérôme's bath scenes and Edouard Debat-Ponsan's *Massage, Hammam Scene* (1883, Musée des Augustins, Toulouse). But it must not be forgotten that many of the harem women shown in these nineteenth-century paintings were supposed to be Circassians with pearly-white skins and that their servants black Africans. The scandal caused by

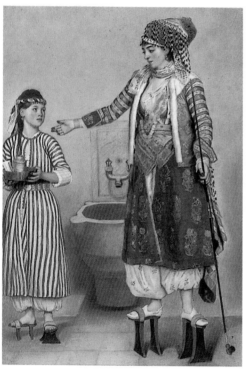

Jean-Etienne Liotard. *Frankish Woman in Turkish Dress and her Servant*, pastel on parchment, 28 x 21 in (71 x 53 cm). Musée d'Art et d'Histoire, Geneva.

Edouard Manet's *Olympia* at the 1865 Salon was due less to the different colour of the two women together and more to the fact that the naked Olympia was seen in a contemporary European context. Although there is no doubt that the Orientalists enjoyed the contrast for purely aesthetic reasons, they were primarily making a social and historical statement.

have extended their interest to pictures of hammams. This "shocking" subject was left to Continental artists such as Théodore Ralli, Francesco Hayez, David Maffei, Vincent Stiepevich and Serkis Diranian. It was above all Jean-Léon Gérôme who treated this theme. His pictures of hammams, dating from the 1870s to the 1890s, were set in Turkey or Cairo,

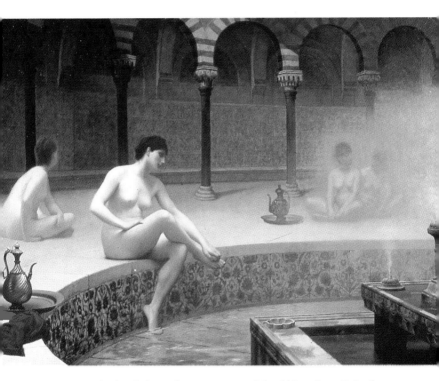

In Victorian England, paintings of nudes survived the climate of official prudery and outwardly high moral standards but, although neo-classical artists such as Sir Lawrence Alma-Tadema painted skittish naked women swimming in Roman marble baths, the English seem never to

Jean-Léon Gérôme. *Steam Bath,* oil on canvas, signed, 28.75 x 39.75 in (73 x 101 cm). Courtesy of the Richard Green Galleries, London.

although he mistakenly called them Moorish rather than Turkish baths. According to the Egyptologist Edward Lane, writing in the 1830s, the Cairo public baths differed little from those in large towns in Asia Minor. He notes that baths were sometimes hired for just two or more families, and that professional singers and dancers were engaged. In order to collect background material for his pictures, Gérôme actually paid a visit to the great hammams in Brusa. There, he sketched "stark naked, perched on a three-legged stool, my box of paints across my knees, my palette in one hand... I felt slightly grotesque." The following account of her visit to a Turkish hammam, written by an Englishwoman, Miss Julia Pardoe, in 1839, could well be a description of a painting by Gérôme: "For the first few moments I was bewildered; the heavy, dense, sulphurous vapour that filled the place and almost suffocated me; the wild, shrill cries of the slaves pealing through the reverberating domes of the bathing-halls, enough to awaken the very marble with which they were lined; the subdued laughter and whispered conversations of their mistresses, murmuring along in an undercurrent of sound; the sight of nearly three hundred women, only partially dressed, and in fine linen so perfectly saturated with vapour that it revealed the outline of the figure; busy slaves passing and repassing, naked from the waist upwards, and with their arms folded upon their bosoms, balancing on their heads piles of fringed or embroidered napkins; groups of lovely girls laughing, chatting, and refreshing themselves with sweetmeats, sherbet and lemonade; parties of playful children, apparently quite indifferent to the dense atmosphere which made me struggle for breath..." The women, she says, would then lie on sofas, where slaves folded them with warm clothes, pour essences on their hair and scatter perfumed water over

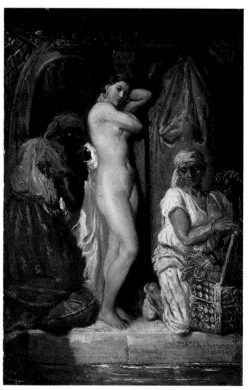

Théodore Chassériau. *Bathing in the Seraglio,* oil on panel, signed and dated 1849, 19.75 x 12.50 in (50 x 32 cm). Musée du Louvre, Paris.

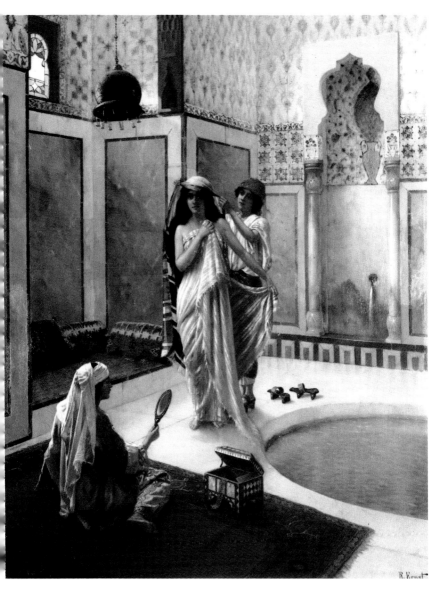

Rudolf Ernst. *After the Bath,* oil on panel,
signed, 43.25 x 31.50 in (100 x 80 cm).
Courtesy of the Galerie Antinéa, Paris.

their faces and hands. Accounts of public baths vary in one detail: did women wear shifts or not? Naturally enough, artists preferred to show them naked !

The true Moorish baths – those of North Africa – were hardly ever painted or drawn before the 1920s, although they were as much a part of everyday Muslim life as in the Near and Middle East. One exception is Louis-Auguste Girardot's *Moorish Bath*, exhibited at the 1903 Salon de la Société Nationale des Beaux-Arts.

In this, a nude is supported by a servant while her leg is dried by a kneeling woman, very much in the same manner as in earlier bath scenes. In a very different vein, a picture by Marius de Buzon, executed in Algiers in 1926, shows women sweating and naked, their rolls of fat and heavy limbs more natural and true to life – although less aesthetic – than the too-perfect creatures dreamed up by Gérôme. Since women would spend all day in hammams, the Algerians entering

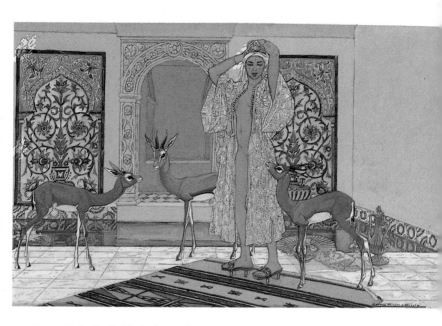

Yvonne Kleiss-Herzig. *The Bath,* gouache, signed, 10.75 x 16.25 in (27 x 41 cm). Private collection.

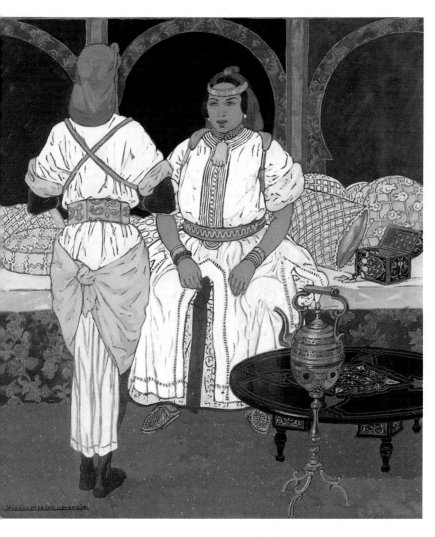

Yvonne Kleiss-Herzig. *Moroccan Interior,*
gouache, signed, 11.75 x 10.75 in
(30 x 27 cm). Private collection.

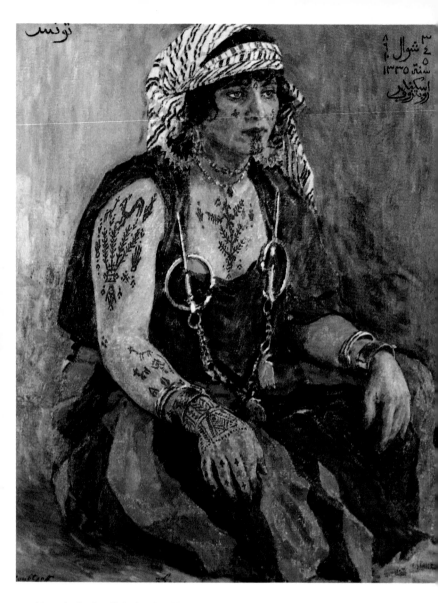

Alexandre Roubtzoff. *Mabrouka*, oil on
canvas, signed and dated Tunis 1917,
inscribed in Arabic, 32 x 24.75 in
(81 x 63 cm). Courtesy of the Galerie
Antinéa, Paris.

he baths in a picture by Jules van Biesbroeck carry baskets that very probably contained food as well as clean linen.

After a morning of being steamed, scrubbed and massaged, there was a pause for refreshments, gossip and entertainments. Then came the task of epilation. This part of a Muslim woman's beauty care, indispensable for both hygienic and erotic reasons, was performed with a powerful arsenic-based paste, a wax mixture or caramel and lemon. The nineteenth-century Orientalists painted naked women with depilated pubises, but it was almost certainly not because they knew about this intimate Eastern custom but because they were complying with the unwritten code whereby female nudes were required to be hairless. The delineation of pubic hair was the prerogative of artists who specialised in pornography or artists who did studies of live models that were not for public view. It has even been speculated that the English art critic John Ruskin, conditioned to the smooth, hairless bodies he had seen in countless pictures of goddesses and nymphs, was unable to consummate his marriage with Effie Gray because of the shock he received on his wedding night on finding that his wife had this normal attribute of womanhood.

Spices and perfumes, for which caravans crossed continents and fortunes were spent, have always held an important place in Islamic countries. They were used not only in the preparation of food and drink and for perfuming coffers in which finery was kept, but also to enhance women's power of seduction. After the hamman, women would splash themselves with rose, jasmin, orange-blossom or geranium toilet water. There were, too, heavier perfumes of almost overpowering strength. Fumigation was another method used, either by holding a cloak over a brazier or a cassolette, as the Moroccan does in John Singer Sargent's *Ambergris Smoke* (1880, Sterling and Francine Clark Institute, Williamstown). The English explorer Samuel Baker recounts that Nubian women would make a hole in the ground inside a tent and throw on the burning embers ginger,

Jan-Baptist Huysmans. *The Beauty Spot,* oil on panel, signed, 7.25 x 9.5 in (18.5 x 24 cm). Courtesy of the Galerie Antinéa, Paris.

cloves, cinnamon, frankincense, sandalwood and myrrh. The woman would then crouch naked, her robe arranged around her so that none of the fumes could escape. This would not only perfume her body but would also, according to a superstition, ward off the evil eye.

A long, slow facial massage, the plucking of facial hair, the whitening of teeth and, finally, make-up completed the various stages of beauty treatment. Henna was used not only to condition and tint the hair, but also to dye the hands, nails, arms and heels. In some countries it was applied in symbolic patterns on special occasions, or to have the *baraka*, or to be blessed, but was generally considered as an adornment. Many artists drew attention to women's eyes rimmed with the *kohl* used to impart sparkle and mystery. Lucien Lévy-Dhurmer,

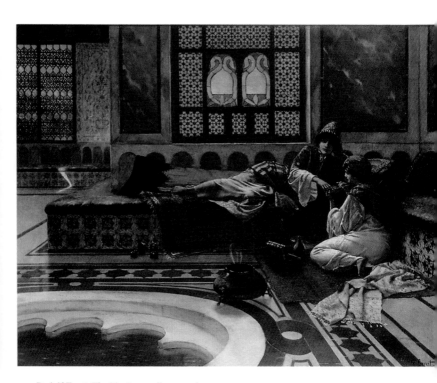

Rudolf Ernst. *The Manicure,* oil on panel, signed, 28.25 x 36.25 in (71.8 x 92 cm). Courtesy of the Gallery Keops, Geneva.

in particular, was fascinated by the effect it gave to bewitching limpid eyes glimpsed above a veil, such as in his evocative painting *Evening Outing*. In *Arab Girls covering their Hair and applying Kohl*, dated 1903, Etienne Dinet shows how *kohl* was used, while Alexandre Roubtzoff, in *Fatmah and Mahboba*, depicts a young Tunisian woman applying *kohl* to her friend's eyebrows. This powder, usually of antimony, was also used in special make-up for ceremonial occasions, as seen on the face of the Algerian bride in Théodore Leblanc's 1835 watercolour, illustrated here. An even more extravagant make-up is used by the women of the Aït Haddidou tribe in Morocco's High Atlas mountains. At the annual *moussems* – traditional gatherings that have come down from ancient times – not only do the young women in search of a fiancé wear *kohl* on their faces but their cheeks are bright with violent carmine patches. Amongst other Berber tribes in North Africa, tattooing was frequent, although few women were so entirely covered with the intricate patterns seen in Alexandre Roubtzoff's portraits of Tunisians. Western women travellers often commented on the magnificence of the clothes and jewellery of the women in the rich harems of the Ottoman Empire; Lady Mary Wortley Montagu was quite ecstatic

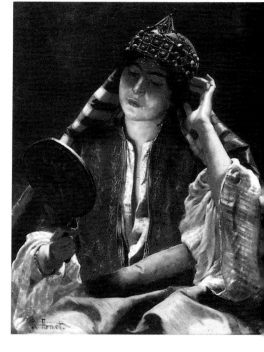

Rudolf Ernst. *The Mirror,* oil on canvas, signed, 28.75 x 23.75 in (73 x 60 cm). Courtesy of the Galerie Arlette Gimaray, Paris.

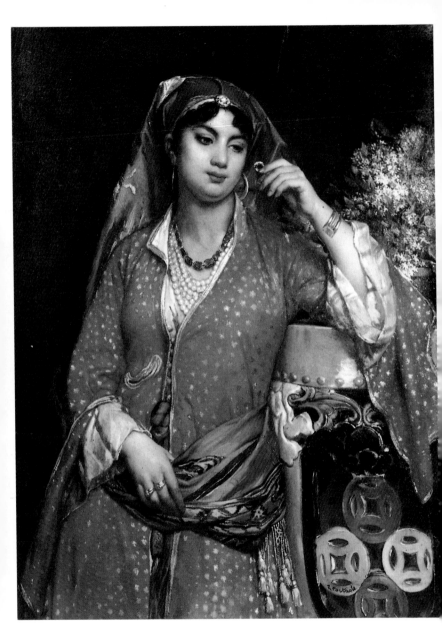

Jean-François Portaels. *Woman with
Jewellery,* oil on panel, signed,
39.25 x 29.50 in (100 x 75 cm). Courtesy
of the Gallery Keops, Geneva.

about her hostess's strings of perfectly white pearls, an emerald as big as a turkey's egg and a girdle of diamonds. The adorning of harem beauties was certainly a theme beloved of the Orientalists; a few examples are Frederic Leighton's *The Light of the Hareem* (1880, Pre-Raphaelite Trust Ltd), John Frederick Lewis's *Indoor Gossip, Cairo* (1873, Whitworth Institute, Manchester), Théodore Chassériau's *Eastern Interior* (circa 1851-52) and Ferdinand Roybet's sumptuous 1872 picture of a spoilt Algerian favourite. In Leighton's picture a young girl holds up a mirror as the stately woman slowly winds her turban unaided, but in most paintings of this kind, servants stand ready to attire their mistresses with finery.

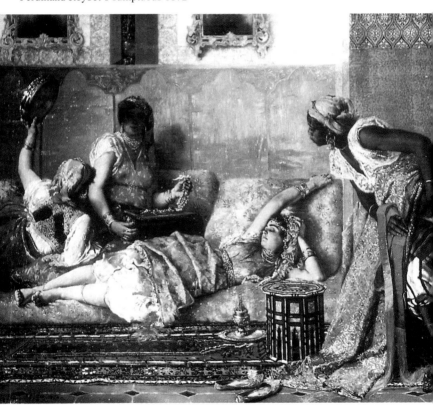

Ferdinand Roybet. *Trying on Finery,* oil on canvas, signed and dated Alger 1872, 47.25 x 59 in (120 x 150 cm). Private collection.

Ceremonies and entertaining

*U*nder the reign of Sultan Ahmed III (1703-1730), there was a continual round of festivities in Constantinople and country residences, featuring balls, banquets and hunting parties. These were attended by the court, Turkish notables, rich Greek Phanariots and prominent members of the European community, including the foreign ambassadors at the Sublime Porte. The more official receptions were recorded by the accredited painter to the sultan, Jan-Baptiste Vanmour. One of his pictures, in the Musée National du Château, Versailles, represents the sultan giving audience to an ambassador and his suite. Oddly enough for someone who knew Eastern customs well, he shows unveiled harem women standing in rows like shy schoolgirls behind the Europeans in their braided jackets and tricorn hats. Another picture by the same artist depicts the fête given by the *grand seigneur* for the marquise de Bonnac, wife of the French ambassador, during which the guests were entertained by gypsy musicians. Illustrations of similar scenes of receptions for foreign visitors in the Eastern world were published in such news periodicals as the *Illustrated London News* and *L'Illustration,* as well as in *Le Tour du Monde,* which serialised travel accounts.

On the other hand, only exceptionally did Orientalist painters show Westerners being offered the hospitality for which Islamic countries are renowned. Raoul Dufy, for example, painted himself, Paul Poiret and Poiret's son Colin, dressed in dinner jackets at a reception given in 1926 by El Glaoui, the pasha of Marrakesh. They were magnificently received during their Moroccan trip, and other Dufy watercolours record these moments. Poiret was particularly impressed by El Glaoui's lavish hospitality, and in his memoirs, entitled *En habillant l'époque* (Paris, 1931), he wrote as follows: "The lavishness of his entertaining is well-known. He has a staff of fifty-two chefs, and on gala occasions each one of them concocts his own individual speciality." The Frenchmen enjoyed a *méchoui*, a couscous and a *pastilla*, the latter being "a wonderful puff-pastry concoction, as big around as the top of a pedestal table." In addition to these classics, they revelled in a dish made from two-hundred scrambled eggs and a salad "consisting of a layer of fennel, a layer of oranges and a layer of chopped chervil, frosted with granulated sugar and glistening like a winter lawn; on the palate, it sings of all the orchard groves of springtime and summer.

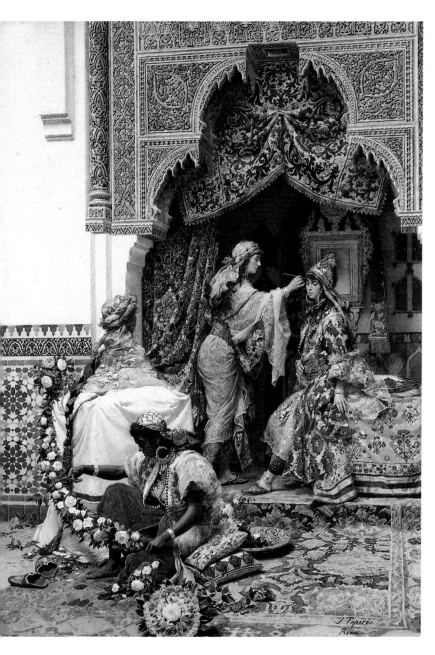

José Tapiro y Bara. *Preparations for the Marriage of the Sherif's Daughter in Tangiers,* watercolour and gouache on cardboard, signed and inscribed Roma, 28 x 19.50 in (71 x 49.5 cm). Private collection.

All these gastronomic treasures, which are the honour of Arab traditions, would amount to very little were it not for the meticulous care devoted to preparing them. There is no hospitality that is more distinguished than this, no welcome that is warmer or more refined." Although their harem visits were not recorded in pictorial form, certain European women did leave numerous accounts of such events in their letters and books. Sophia Poole, who lived in Egypt in the 1840s, was frequently invited. At one luncheon, "the tray was covered with small silver dishes, filled with various creams, jellies, etc., and most tastefully garnished with exquisite flowers. Ladies attended close to our divan with fly-whisks, behind them about thirty formed a semi-circle of gaily-dressed and in many cases beautiful women and girls, and those near the door held large trays on which black slaves who stood without placed the dishes, so that the table might constantly be

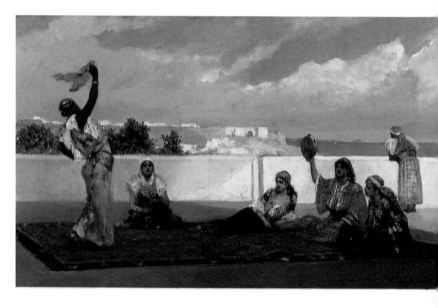

Benjamin-Constant. *The Scarf Dance,* oil on canvas, signed, 24 x 39.50 in (61 x 100 cm). Vassar College Art Gallery, Poughkeepsie.

replenished." She noted, however, that "it would be a breach of etiquette and contrary to harem laws, were I to describe *particularly* the persons of the wives of the Pasha, or any lady, after distinguishing her by her name of her situation in a family." It was, she said, customary to give a present to the chief eunuch or door-keeper on leaving the house. Accompanied by servants and

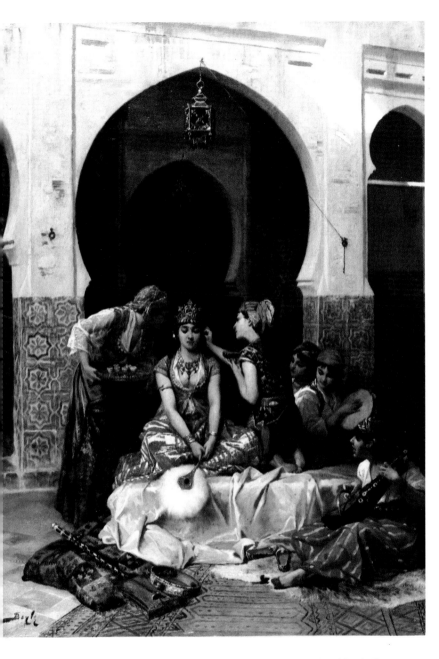

Pierre-Marie Beyle. *Bridal Finery, Algeria,* oil on canvas, signed,

38.50 x 27.75 in (97.6 x 70.2 cm). Courtesy of the Galerie Casa-Bella/Intemporel, Paris.

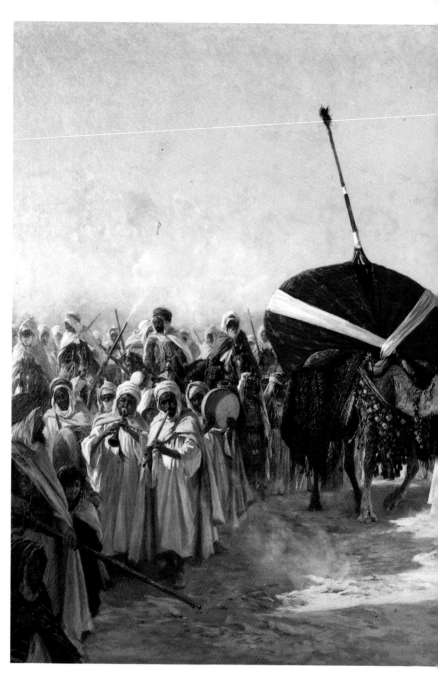

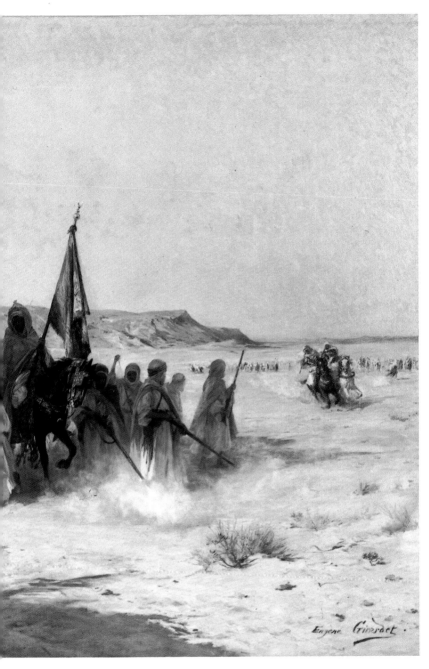

Eugène Girardet, *A Bridal Procession in Southern Algeria,* oil on canvas, signed, 50.75 x 72.50 in (129 x 184 cm). Private collection.

91

children, harems would visit one another, bringing gossip and news from different areas of the town, exchanging beauty recipes and showing off their new dresses. Normally, these visits were announced beforehand and any previous plans gracefully given up. In Egypt, at least, there were surprise visits, in which case the guests would not wear their best clothes in order not to embarrass their hosts. If there was a guest of honour, friends would be invited, special refreshments offered and fanciful or facetious stories told. The women might play musical instruments or beat drums and tambourines, as in Emile Bernard's *Harem* (1894, Musée National des Arts d'Afrique et d'Océanie, Paris) and the strange and dream-like *Egyptian Harem Fantasy*, by Richard Dadd (1865, Ashmolean Museum, Oxford). Foreigners were generally dismayed at having to listen to Eastern music, finding it cacophonous. Théophile Gautier, however, discerned its poetry: "These frail, quavering melodies resound like the susurration of solitude, like the voices of the wilderness that speak to the soul lost in the contemplation of space; they stir strange nostalgias, dredge up infinite memories and conjure forth previous existences that come straying back in random array." (*Voyage pittoresque en Algérie,*

1845). Many nineteenth-century Continental Orientalists painted dancers in harems as though dancing were a customary entertainment. In these works, it is never quite clear whether these are harem women performing for their own or the masters' entertainment or whether they are professionals – who would have been hired only on exceptional occasions. Georges Clairin's *Harem Dancer,* shown at the 1911 Salon de la Société des Artistes Français, is a particularly extravagant example of pure fantasy. In a Hispano-Moorish palace, an Ouled-Naïl woman sits looking glum. On the left, female musicians are frantically playing while other women lie gazing delightedly at the central figure. She is in the last stages of the dance of the seven veils; these are so transparent that one wonders why she bothers to remove them at all. As for the dancers in Narcisse Diaz de la Peña's paintings of the 1860s, they are – whether he calls them Algerians, *almehs*, Turks or gypsies – as imaginary as the *turqueries* of the eighteenth century.

For the most part, artists showed dancing as more restrained and modest, although Western women visitors were shocked by something so alien to them. Lady Mary Wortley Montagu, as open-minded as always, found the music so sweet in a harem she visited, the women's movements so languishing that "I

could not help thinking that I had been sometime in Mahomet's paradise, so much was I charmed by what I had seen."

Another surprising remark for a mid-Victorian woman of her social position comes from Lady Duff Gordon. After watching a dancing-girl moving her breasts by some extraordinary muscular effort, first one and then the other, she found that breasts could be the most beautiful things in the world: "They were just like pomegranates and gloriously independent of stays or any support."

A few artists, and in particular Mohammed Racim, painted professional dancers performing at all-male parties in private Algerian houses. In Racim's miniatures, the movements of the entertainers are formal and stately, the expressions of the spectators impassive. Women and children watch from second-floor windows or balconies.

Language was not always a barrier between visitors and their hosts, for many of the more seasoned Western travellers spoke Arabic or Turkish (although the Arabic of Lady Anne Blunt, wife of the pan-Islamist and

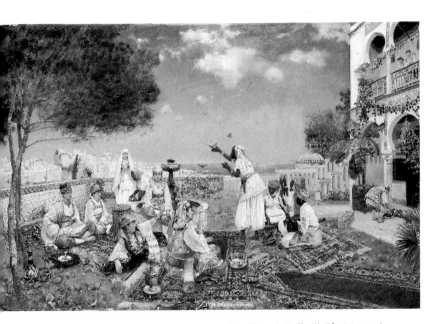

Jean-François Raffaëlli. *Black Entertainer*, oil on canvas, signed and dated 1877, 35.75 x 36.25 in (60 x 92 cm). Private collection.

Arabophile Wilfred Scawen Blunt, was so perfect and so classical that hardly anyone could understand a word she said). It was rather that the customs of the Eastern and Western worlds were often incomprehensible to each other. Mrs. Harvey, writing in 1871, found that "The first visit to a Hareem is a very exhausting business, for everybody feels shy and everyone is stupid and the stupidity and shyness last many hours." Lady Anne was, however, entertained in a novel way in 1878 when she visited the notoriously cruel ruler of Hail in Jabal Shammar, Emir Muhammad ibn Rashid. The emir produced "one of those toys called telephones which were the fashion last year in Europe. This the emir caused two of his slaves to perform with, one going into the courtyard outside, and the other listening." Mabel Bent and her very amateur explorer husband Theodore, whom she had accompanied on many previous journeys, were the first Westerners to go to Al Hafa, in Oman, in 1894. The wali's harem brought her

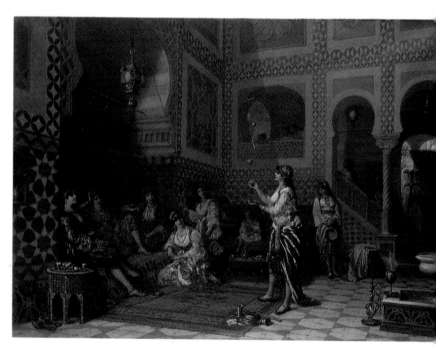

Jan-Baptist Huysmans. *Jugglers in the Harem, Algeria*, oil on canvas, signed and inscribed on the stretcher, 28.50 x 39.25 in (72.5 x 100 cm). Private collection.

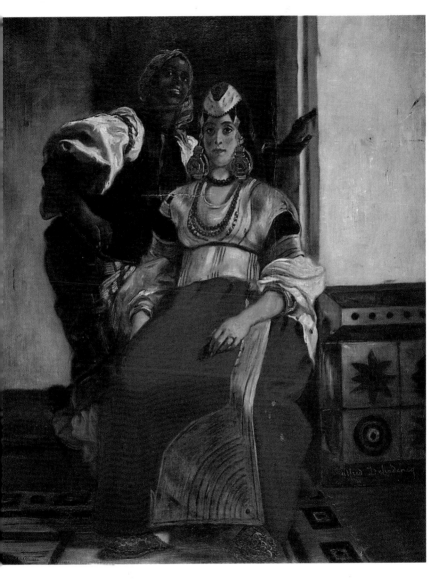

Alfred Dehodencq. *Jewish Bride in Morocco,* oil on canvas, signed, 36.25 x 29.25 in (92.2 x 73.9 cm). Musée Saint-Denis, Reims.

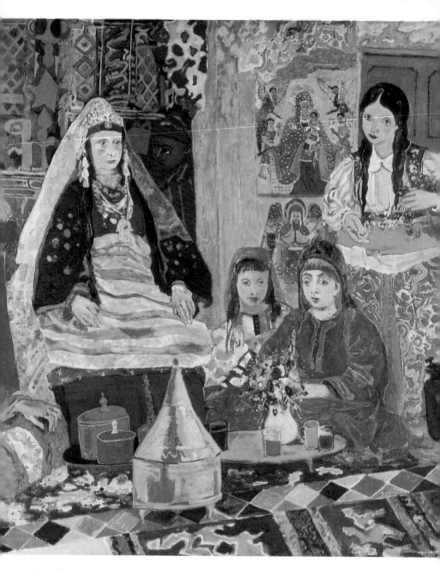

Roger Bezombes. *Moroccan Bride,* oil on canvas, signed, 10.75 x 8.75 in (27 x 22 cm). Courtesy of Roger Bezombes, Paris.

Théodore Leblanc. *Muslim Woman's Visiting Costume for a Marriage,* watercolour, dated 10 bre '35, 11.25 x 8.50 in (28.6 x 21.6 cm). Cabinet des Estampes, Bibliothèque Nationale, Paris.

"embarrassing" presents of tamboul leaves and lime, which dyed her teeth red. To cap everything, Mrs. Bent found that the main topic of conversation was the merits of European underclothing. The apparel of European women was indeed a great source of curiosity to the harem women. Lady Mary Wortley Montagu wore a Viennese court dress in order to impress when invited in 1817 to the grand vizir's residence in Constantinople, while Isabel Burton in the 1860s was sometimes persuaded to entertain harems in Syria by wearing her most décolleté gown and describing in detail her coming-out ball at Almack's in London. The women thought low necks and waltzing "very dashing." Despite Isabel's romantic adulation for everything Arab, one of her receptions at the consulate in Damascus caused great fuss and upset. Her strong but misguided feminist feelings made her place the Muslim wives in chairs and expect their husbands to pass them cakes and cups of coffee, violating every tradition of the Islamic home. Not all receptions between women took place in the closed harem quarters. Many artists show groups of women entertaining or being entertained on terraces, in gardens or in patios. Often open to the sky, patios, the central courtyards of houses, surrounded by arched columns and decorated with

Théodore Leblanc. *Haroufoah; Muslim Bride,* watercolour, annotated, dated 9 bre '35, 9.25 x 6 in (23.5 x 15 cm). Cabinet des Estampes, Bibliothèque Nationale, Paris.

brightly-coloured faience tiles, were pleasantly cool.

Many of the ceremonies, festivities and rites of the Eastern world, with their complex rituals and rich traditions, were generally not witnessed by Westerners, nor did the latter even suspect their existence. Weddings, however, with their lengthy preparations and often spectacular scenes of hospitality, were relatively accessible. Eugène Delacroix and Alfred Dehodencq painted only Jewish weddings, but Théodore Leblanc, who visited Algiers in 1835, just five years after the seizing of the town by the French, managed to make several watercolours of Muslim brides. He also painted guests in their finery during the eight-day-long celebrations. In a painting by Carl Haag of a Damascus marriage procession, the bridal couple are preceded by a richly caparisoned camel mounted by a young man

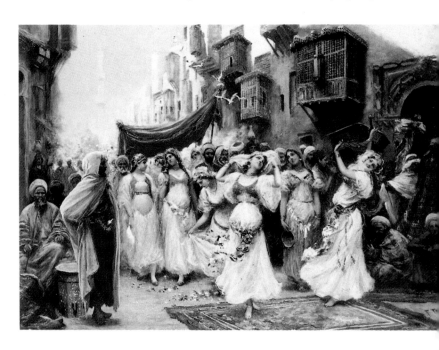

Fabio Fabbi. *Procession in Cairo,* oil on canvas, signed, 24 x 34.25 in (61 x 87 cm). Private collection.

Otto Pilny. *Dancer with a Tambourine,* oil on canvas, signed and dated 1909, 47.50 x 31.75 in (120.6 x 80.2 cm). Courtesy of the Gallery Keops, Geneva.

Edouard Richter. *Eastern Dancer,* oil on canvas, signed and dated 1883, 36.50 x 25.75 in (100 x 65 cm). Archives Berko Fine Paintings, Knokke-Heist.

playing kettle drums. Behind them, family, friends and musicians pour through the narrow street. As a holy city, Damascus was never an easy place in which to paint, particularly not in 1859, the date of Haag's visit. However, on his painting expeditions, he was often accompanied by the notorious Englishwoman Jane Digby, who by then was married to her great love, Sheikh Abdul Medjuel El Mezrab, and totally accepted by her husband's tribe. A picture by Narcisse Berchère of an Egyptian wedding procession shows all the excitement and curiosity of the villagers as the bridegroom in his scarlet coat goes to meet his bride. In other pictures of country weddings, such as Marius de Buzon's *Kabyle Wedding*, of 1935, the bride is shown riding on a mule; in Gustavo Simoni's painting, she is carried in a *bassour*, or palanquin, on camel-back, a more usual method of transport in the Maghreb on these occasions. In Jules Taupin's *Dressing the Bride, Algeria*, exhibited at the 1902 Salon de la Société des Artistes Français, a seated young girl admires herself in a mirror while a companion pins a fibula on her shoulder and another drapes a veil over her head. Other artists, such as Pierre-Marie Beyle, Mohammed Racim, José Tapiro y Bara and Gaston Saintpierre preferred to depict more sophisticated weddings, since the last-minute preparations of the bridal finery and the celebrations gave them an opportunity of painting with minute care the magnificent costumes and jewellery.

Besides the personal, family celebrations such as births,

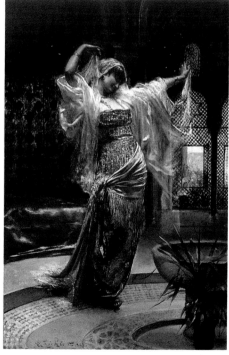

circumcisions, betrothals and marriages, there were those of a more religious nature, for instance, the departure and arrival of the *mahmal*, the sacred carpet that was taken every year to Mecca from Cairo on the greatest of all pilgrimages. Women undertook this *hadj* to the holy city and they were also present in the crowd that gathered to acclaim travellers as they returned from their long journey, as can be seen in Ludwig Deutsch's large 1909 painting *Procession of the Mahmal in Cairo* and Carl Haag's 1894 *Mecca Pilgrims Returning to Cairo.* Auguste-Alexandre Hirsch, in *Return of the Hadjis* (1880), shows women waiting on their terrace, not in the street. Women entering or in mosques or partaking in religious ceremonies are rarely seen in Orientalist works. This was perhaps through discretion on the part of artists. The writer and painter Eugène

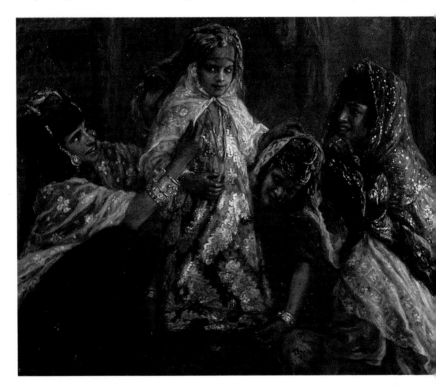

Etienne Dinet. *Festival Dress,* oil on canvas, signed and dated 1907, 32 x 39.25 in (81 x 100 cm). Private collection.

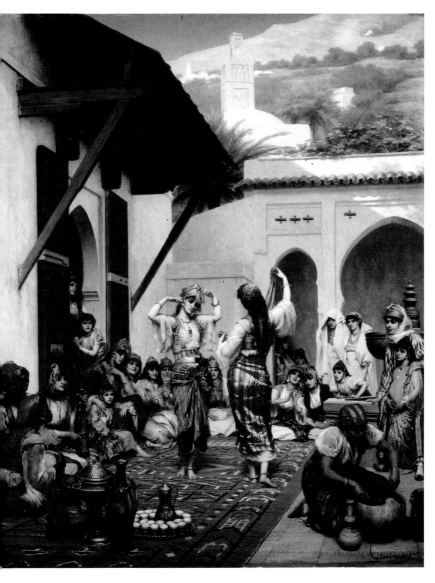

Gaston Saintpierre. *Chetahate (The Dancers): Women's Fête in an Arab Wedding in Tlemcen, Oran Province,* oil on canvas, signed, 46.50 x 37.50 in (118 x 95 cm). Courtesy of the Gallery Keops, Geneva.

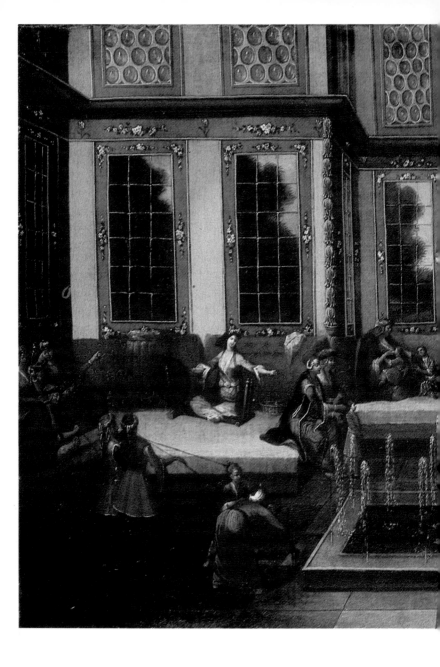

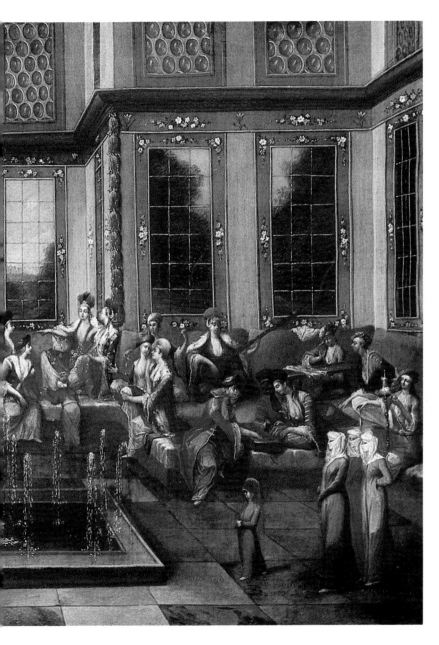

Jan-Baptiste Vanmour. *Reception in a Turkish Harem,* oil on canvas, 23 x 55 in (58 x 89.2 cm). Courtesy of Christopher Gibbs Ltd., London.

Fromentin, for one, was quite firm about this point: "I deem it unseemly curiosity that prompts one to penetrate Arab existence any more deeply than is permitted. This people should be considered from the distance at which it prefers to show itself: its men, from close at hand; its women, from afar; and the bedroom and mosque, never. In my opinion, describing a woman's apartment or reporting on Arab religious ceremonies is an offense worse than fraud; it amounts to committing, under the guise of art, an error of viewpoint." (*Un été dans le Sahara*, Paris, 1856). He did, however, make a drawing of women on their way to Friday prayers in the mosque of Aïn Madhi near Laghouat. "The women were coming in from the sunlight, hugging the walls, quickening their steps, especially when they passed in front of us, in order to escape quickly from the gaze of the unbeliever." There is also an unusual picture by the Scottish artist Sydney Adamson, entitled *Turkish Women at Prayers* (circa 1916, Musée d'Orsay, Paris). As a convert to Islam, Etienne Dinet was sharply aware of the spirituality of the Algerian people amongst whom he had made his home. He showed a *Muslim Woman at Prayer on the Terrace of her House,* published in his book entitled *La Vie de Mohammed* (1918), and did a painting of *Muslim Women emerging from a Village Mosque* (1918, National Museum of Western Art, Tokyo), In André Suréda's *Moroccan Festival* (Musée National des Arts d'Afrique et d'Océanie, Paris), women watch a pilgrimage coming from the mortuary monument of a local saint; the procession is accompanied by flag bearers and musicians. Suréda, Dinet and Marius de Buzon were three artists

Mohammed Racim. *Dancers (Old Algiers),* miniature, gouache heightened with gold, signed and inscribed Alger in French and Arabic, 7.25 x 5.25 in (18 x 13 cm). Private collection.

who portrayed women inside a *koubba*, which would be hung with strips of material by which the believer hoped to attract the saint's attention to the troubles he does not have the strength to bear by himself. Another unusual picture, *The Sacred Well of Sidi-Bou-Medina* (1913) by Gabriel-Charles Deneux, shows Algerian women inside the *koubba* of the twelfth-century *marabout*, or saint, drawing holy water from a well whose marble walls are deeply grooved by the rubbing of chains over the years.

Nineteeth-century travellers often sketched burial grounds in Asia Minor, showing the headstones of the graves carved with a representation of the deceased person's turban or headgear and, for women, floral forms. Only a few

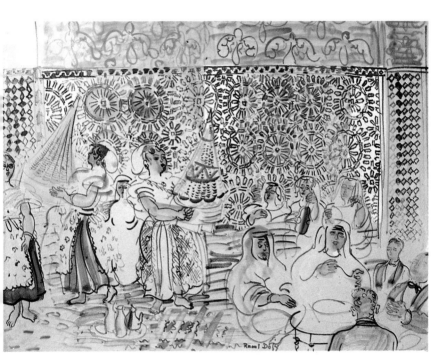

Raoul Dufy. *Couscous Served at the Residence of the Pasha of Marrakesh,* watercolour and gouache, signed, 19.25 x 25.50 in (49 x 65 cm). Private collection.

artists, Georg Emanuel Opiz, Thomas Allom and Jules Laurens, for instance, showed Muslim women paying their respects to their dead. This subject was mainly treated by twentieth-century painters in the Maghreb such as Henri Hourtal, Etienne Dinet, Louis-Auguste Girardot, Jules Taupin, Edouard Herzig and André Suréda. In his *Tableaux de la Vie Arabe* (Paris, 1908), Dinet writes as follows: "Every Friday, which is the day of religious observance for the believer, a long line of veiled women accompanied by children wends its way along the cemetery road, like a row of reeds along a river. The women love the cemetery: for them, it means a temporary reprieve from the generally cloistered condition imposed on them by the laws of Islam; it represents a destination for an outing; and the tears they shed for the departed provide relief for their worries." Probably the best-known

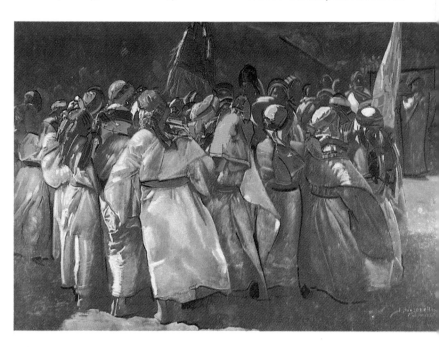

Jacques Majorelle. *A Day of Pilgrimage,* tempera and mixed technique heightened with metallic powders, signed and inscribed Marrakech, 28 x 39.25 in (71 x 100 cm). Courtesy of Huguette Portefaix, Paris.

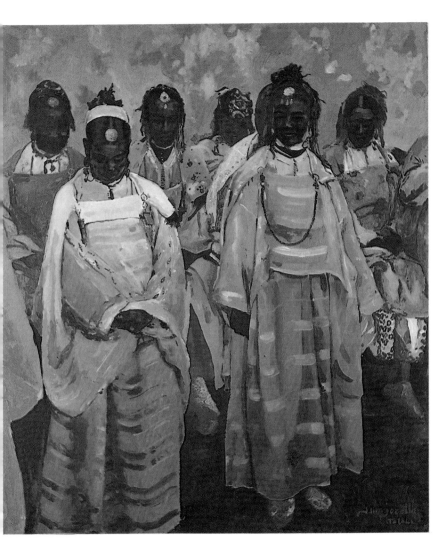

Jacques Majorelle. *Moroccan Dancers
at Telouet,* oil on canvas, signed and
inscribed Telouet, 35.75 x 30.75 in
(91 x 78 cm). Private collection.

pictures on this theme are Paul-Elie Dubois's *Peace in Light* (1923, Musée National des Arts d'Afrique et d'Océanie, Paris) and *In the El-Kettar Cemetery* (1922, formerly in the Metropolitan Museum of Art, New York). Women would go to this large cemetery on the heights of Algiers to leave myrtle on the tombs. In two attractive pictures, Frederick Arthur Bridgman depicts Algerian women in the Oued-el-Kebir cemetery in Blidah celebrating the feast of the Mouloud, the anniversary of the birth of the Prophet Mohammed. In one of these, shown at the 1889 Paris Universal Exhibition, a young girl obtains light from the flame of the candle held by one of a group of women. In the background, shrouded ghost-like figures surround the *koubba,* which

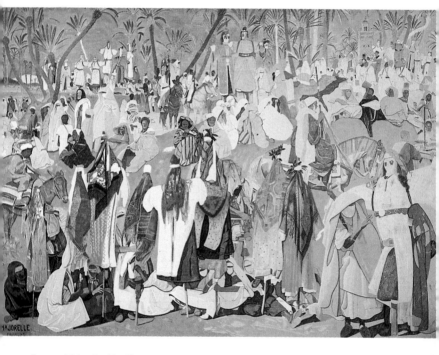

Jacques Majorelle. *The Alamats,* or *Moroccan Dolls,* or *The Alamates, Women with Dolls,* tempera heightened with silver, signed and dated Marrakech 1931, 112.25 x 157.50 in (285 x 400 cm). Banque Commerciale du Maroc, Casablanca.

glows from the burning candles inside. Etienne Dinet, in *The Night of the Mouloud*, has recorded a less solemn moment; two young girls walk through a street at night, lit up by the crackling flame of a burning palm frond. Dancing and singing were notable features during the great religious festivals and the local *moussems*, or gatherings. They were either purely of a sacred nature or more-or-less profane, but were an essential part of the rites, not for personal entertainment. This subject was treated by Auguste Renoir in his *Arab Festival, Algiers (The Casbah)* (1881, Musée d'Orsay, Paris). Here, dancers at the Aïd-el-Kebir, or feast of the sheep, are encircled by a crowd of spectators.

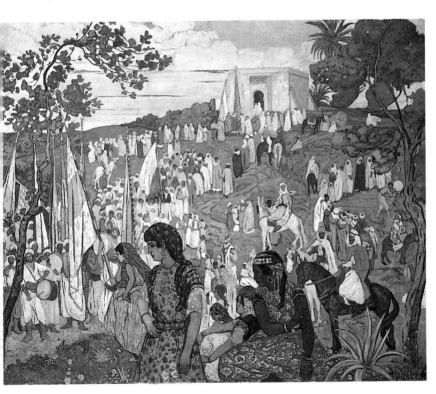

André Suréda. *Moroccan Festival*, oil on canvas, 74.75 x 87.75 in (190 x 230 cm). Musée National des Arts d'Afrique et d'Océanie, Paris.

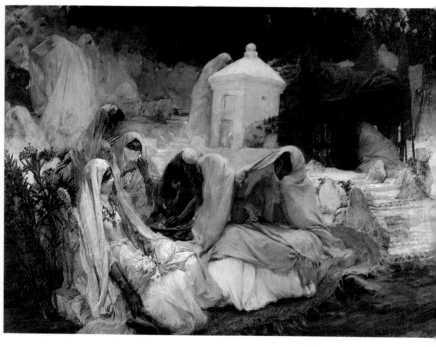

Frederick Arthur Bridgman. *Feast of the
Prophet at Oued-el-Kebir*, oil on canvas,
signed, titled and inscribed Blidah, Algérie,
59 x 78.75 in (150 x 200 cm). Private
collection.

Alfred Chataud. *After the Circumcision
Ceremony,* oil on panel, 11 x 5.75 in
(28 x 14.7 cm). Private collection.

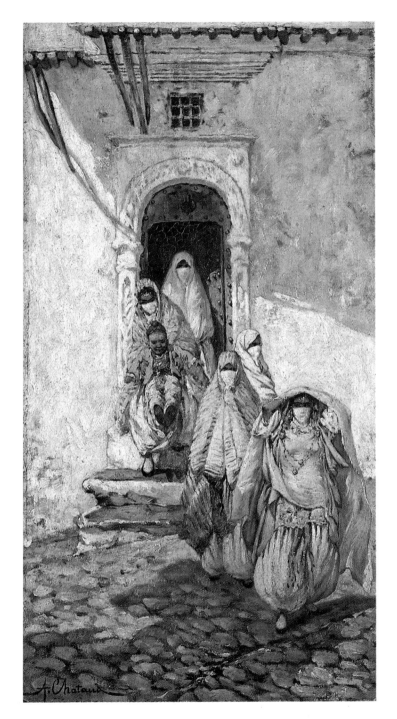

A. Chataud

Seduction

*T*he word odalisque is derived from *oda*, which literally means "room" or "chamber"; in the Turkish seraglio, it denoted the court of each of the most important women in the harem. On entering the royal harem at an early age, girls, abducted from their native lands, would in all probability be attached to one of these *odas* as novices in order to perfect themselves in the different spheres allotted to them in the household system. They thus took the name of odalisques. Since they were slaves, they were, in the imagination of the Romantics, prisoners who dreamed of liberation. In *Les Orientales* (1828), for instance, Victor Hugo describes the musings of a captive watching the moonlight on the sea. Moreover, since the seraglio – and, by extension, all large harems – were, in Western fancy, places of hedonism and unbridled passions, odalisques were portrayed as languid creatures surfeited with sensual pleasures. They were generally portrayed nude or lightly clothed, since they existed, so it was thought, only to serve and satisfy the sultan or their masters. In actual fact, however, Eastern women's bodies were largely covered up, often with many superimposed layers of clothing. The seraglio harem was, moreover, ruled by strict Court etiquette and discipline. A concubine lucky enough to be chosen to make a nocturnal visit to the sultan was led to his rooms in silence and utmost secrecy. It was only when she was given a rise in rank and her own quarters and slaves that the other women became aware of the honour accorded to her. As for those who had never caught the sultan's eye, they were assigned menial tasks that filled their empty and frustrated lives. Odalisques were frequently depicted in recumbent positions and exquisitely formed. This tradition of painting reclining nudes goes back to the Venetian Renaissance, with Giorgio Giorgione's *Sleeping Venus,* of circa 1510. This was followed in the 1540s by Titian's series of pictures of Venus, in which the goddess lies supported by her left arm, her body turned round towards the beholder. In many of these scenes, a male admirer is seated at her feet, playing music, a theme widely used later by the Orientalists. In this long line of pictures, the nudes were shown as being both self-contained and supremely confident of their perfect beauty: there is no apparent intent of arousing sexual interest. Another element is introduced in Francisco Goya's *La Maja desnuda* (1798-1800). Here, the naked Andalusian displays her body in a provocative

Etienne Dinet. *The Djouak*, oil on canvas, signed, 39.25 x 32 in (100 x 81 cm). Private collection.

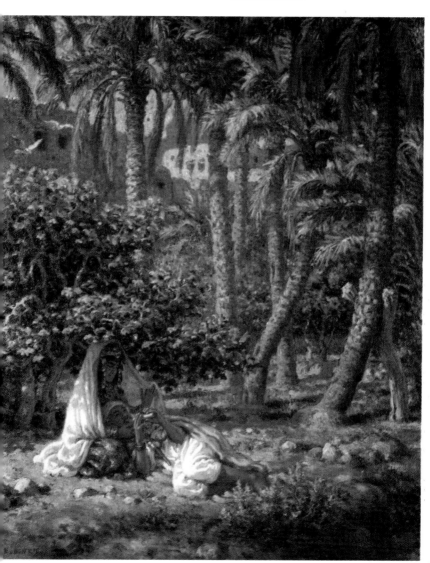

manner. Her breasts are pulled up as she puts her hands behind her head and she seduces the spectator with her eyes; there is a suggestion of a potential amatory exchange. These two tendencies, ideal perfection and eroticism, were combined in the series of odalisques and bathers by Ingres. *The Great Odalisque* (1814, Musée du Louvre, Paris) is casting a cool glance over her shoulder, as though she is daring anyone to take advantage of her exposed body. Here, the artist has transformed a classical nude into a specifically Oriental subject by the addition of a multi-coloured turban, a peacock-feather fan, a narghile and an incense-burner. In his *Odalisque with Slave* (1839, The Fogg Art Museum, Cambridge; 1842 version,

Walters Art Gallery, Baltimore), the sensual content is more pronounced. The languorous odalisque lies stretched out across glistening fabrics, enraptured by the music played by her slave. With her thrown-back head, loosened hair and raised arms, she conveys both abandon and acquiescence. Although she is ostensibly luxuriating in a feeling of well-being, the motionless, watching figure of a black eunuch in the background introduces a disturbing outside element. By the mid-nineteenth century, the demand for nudes in paintings and sculpture was greater than ever before. Pictures of these naked or semi-naked odalisques were, however, almost entirely the prerogative of Continental artists.

Auguste Renoir. *Woman of Algiers* or *Odalisque*, oil on canvas, signed and dated '70, 27.50 x 48.25 in (69.2 x 122.6 cm). National Gallery of Art, Washington, Chester Dale collection.

Rudolf Ernst. *The Favourite,* oil on panel,
signed, 36.50 x 28.25 in (93 x 71.5 cm).
Courtesy of Christian Meissirel Fine Art,
Paris.

Victorian England had an opulent, powerful and expanding society, and the average middle- and upper classes had an unflinching faith in their country's destiny. Not surprisingly, they had a great admiration for classical Greece and Rome, and the neo-classical painters celebrated the perfect human body as being consistent with high ideals, purity and innocence. The tacit code of respectability allowed nudes, but only if they were presented as idealised goddesses whose natural deformations had been ironed out. Even then, drapery or the woman's hand shielded – but did not always obscure – her pubic area. The new class of art patrons, manufacturers, shipowners and financiers, particularly those from the English Midlands and North America, cared little, however, about these high-minded sentiments, and frankly revelled in pictorial nudity. They bought not only the flagrantly

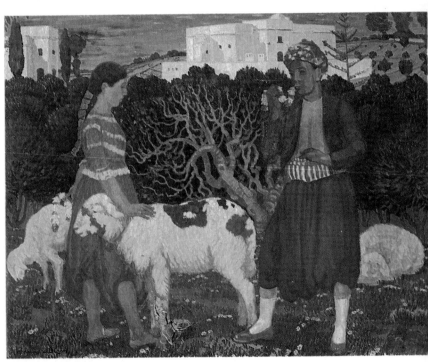

Marius de Buzon. *Romance in the Algerian Springtime*, oil on canvas, signed and dated 1924, 51 x 63.25 in (130 x 160.5 cm). Private collection.

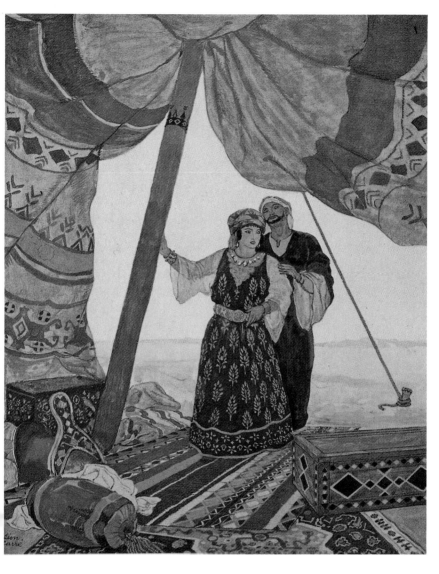

Léon Carré. *And he Led me into his Finely-
coloured Tent,* illustration for *Le Livre des
Mille et Une Nuits* (1926-1932), signed.

sensual nudes exhibited at the Royal Academy in London but also those at the Paris Salons. This "great frost of Victorian prudery", as Kenneth Clark called it, meant that it remained unacceptable in England to do paintings of odalisques, who conveyed an aura of depravity and sexuality. The word "Turkish" was already synonymous with naughtiness in eighteenth-century England, judging from the number of indiscreet encounters involving characters in Turkish dress at masquerades. The pornographic novel entitled *The Lustful Turk* (1828) leaves the reader in no doubt. The heroine, captured by Turkish pirates off the Barbary coast, is taken to the dey's harem in Algiers. The theme of this story (in which the martyr turns into a willing victim) is one of domination, chastity broken and pride subdued, followed by the young Englishwoman's eager responsiveness to the dey's prowess

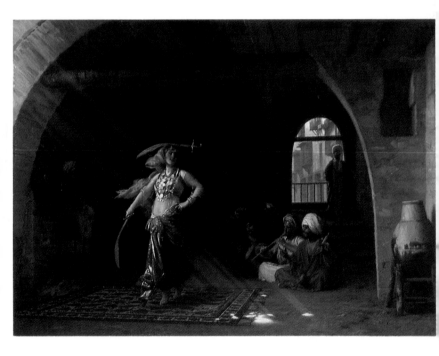

Jean-Léon Gérôme. *Sword Dance in a Café,* oil on canvas, signed, 23 x 31.50 in (58.5 x 80 cm). Herbert F. Johnson Museum, Cornell University, Ithaca.

Jean-Léon Gérôme. *Woman of Cairo,* oil on canvas, signed, 32 x 25.50 in (81.2 x 64.7 cm). Courtesy of the Mathaf Gallery, London.

and skill. Later in the century, "Turkish" became practically a code word for indecency, as it evoked fantasies of virile pashas and carnal delights. Oddly enough, the plump, overstuffed armchairs, love seats, ottomans and sofas that were to be found in polite drawing-rooms were known all the same as "Turkish" furniture. Despite the sub-culture of popular jokes and bawdy skits, songs and slang, the Victorian Establishment remained moralistic and prudish, although Isabel Burton's blameless "household edition" of her husband's translation of *The Arabian Nights* had poor sales after the uproar created by the risqué unexpurgated version.

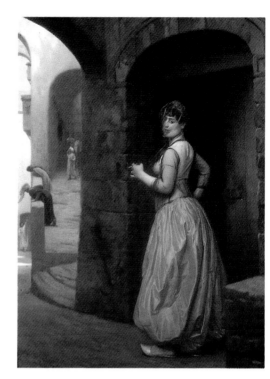

For many Continental academic artists, as high-minded as their English counterparts, white and waxily-perfect female bodies were also an ideal; pictures of these improbable creatures were reproduced in such publications as *Le Nu au Salon* and, for photographs, in *Le Nu Artistique*. Despite double standards, the social climate on the Continent was considerably more liberal than in England. Provocative portrayals of 'Eastern' women need not, therefore, be restricted to the privately-circulated photographs in which models posed as Fatma, Theodora or a newly-captured slave, but could be seen in paintings

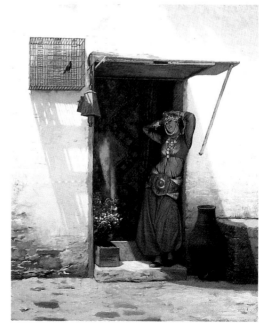

Jean-Léon Gérôme. *Woman of Cairo at her Door,* oil on canvas, signed, 32.25 x 26.25 in (82 x 71 cm). Syracuse University Art Collection.

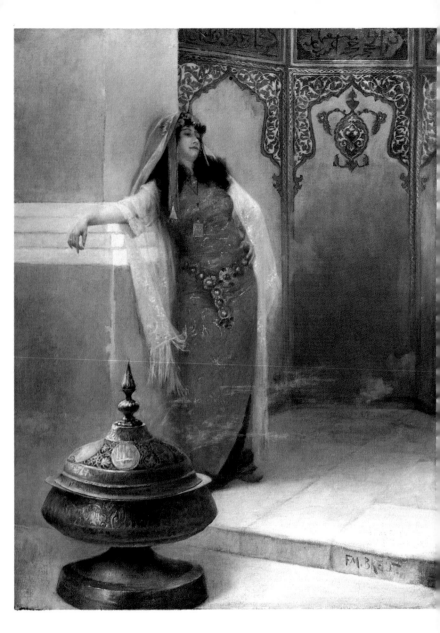

Ferdinand-Max Bredt. *Dreaming,* oil
on canvas, signed, 35.75 x 27.75 in
(91 x 70.5 cm). Courtesy of the Mathaf
Gallery, London.

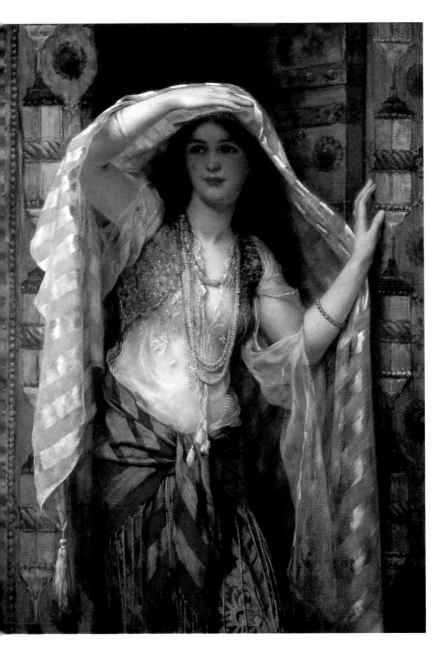

William Clarke Wontner. *Safie, One of the Three Ladies of Bagdad,* oil on canvas, signed and dated 1900, inscribed on a label on the frame, 50 x 37.50 in (127 x 95 cm). Private collection.

intented for public view. This was all the more true because the Eastern settings, remote and exotic, allowed the artists to get away with a good deal more overt eroticism than if the same subject had been treated in a European context.

In most of these paintings of odalisques, one of the Orientalists' favourite themes, the presence of the man, the seducer, is felt but not seen; his place is taken by the beholder of the picture. As in pornographic literature, the male, by dominating and possessing, can transform submission into passion, and therefore these odalisques are seen enticing with their eyes and their bodies. It is, however, extremely rare to find an Orientalist painting in which the woman is shown as sexually satisfied (as in Benjamin-Constant's *The Sharifas* (1884, Musée des Beaux-Arts, Carcassonne, replica, Musée des Beaux-Arts, Pau), although this was shown in François Boucher's licentious scenes and other eighteenth-century paintings, as well as in privately circulated erotica. The scandal caused at the 1878 Paris Salon by Henri Gervex's *Rolla*, removed from the walls as being an affront to public morals, was due not

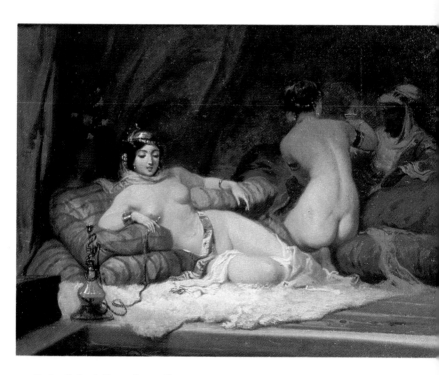

Eugène Guérard. *Harem Scene,* oil on canvas, signed and dated 1851, 12.75 x 16.25 in (32.5 x 41 cm). Private collection.

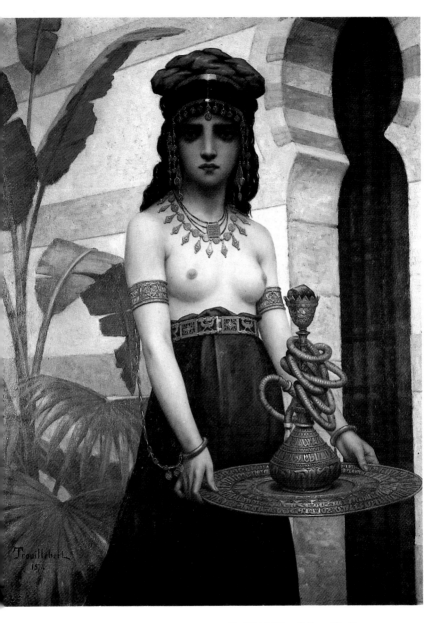

Paul-Désiré Trouillebert. *The Harem
Servant,* oil on canvas, signed and dated
1874, 51.25 x 38.25 in (130 x 97 cm).
Musée des Beaux-Arts Jules Chéret, Nice.

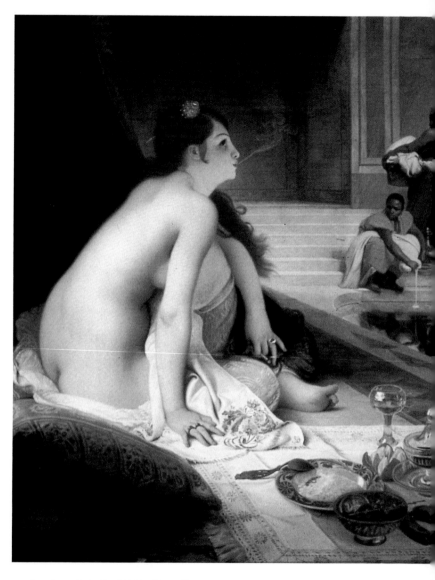

Jean Lecomte du Nouÿ. *White Slave*, oil
on canvas, signed and dated 1888,
59 x 46.50 in (149.5 x 118.3 cm).
Musée des Beaux-Arts, Nantes.

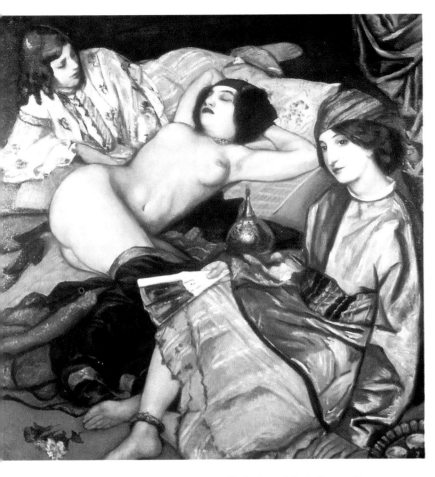

Emile Bernard. *In the Harem,* oil on
canvas, signed and dated 1912,
47.75 x 47.75 in (121 x 121 cm). Private
collection.

to the suicide of Alfred de Musset's debauched hero, but to the fact that the *fille de joie* lying naked on the tousled bed had obviously spent an extremely agreeable night of love. The theme of the *femme fatale* recurs frequently in both Orientalist and Symbolist paintings. These implacable Judiths and Salomes use their irresistible power of fascination in order to destroy. As in Léon Bakst's *The Yellow Sultana* (1916),

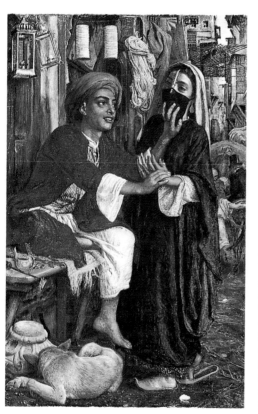

William Holman Hunt. *A Street Scene in Cairo: the Lantern Maker's Courtship*, oil on canvas, 21.50 x 13.75 in (54.6 x 35 cm). City Museum and Art Gallery, Birmingham.

with her sultry look and overwhelming carnality, they are no spiders spinning their web of seduction like the odalisques; rather they are praying mantises ready to devour the unsuspecting male. Other erotic fantasies are seen in pictures such as Jacques Wely's 1897 watercolour in which an Arab sheik dreams of tempting women who appear amidst the heady fumes rising from an incense-burner. In Jean Lecomte du Nouÿ's *Khosru's Dream* (1874, Mrs. Noah L. Butkin Collection, Shaker Heights, Ohio), inspired by Montesquieu's *Lettres Persanes*, a eunuch lies in drugged stupefaction on a terrace. In the smoke coming from the bowl of his *chibouk,* the ethereal figure of the slave Zelide takes the form of a *houri*, that creature so divinely beautiful that all the faithful will find her kind in paradise.

In only a few Orientalist paintings does one find the master being pampered by the women of his harem. This could perhaps be explained by the fact that most of the nineteenth-century European artists came from middle-class families for whom love and marriage were subordinate to financial considerations. Romantic feelings were very definitely relegated to the background. The man was the undisputed head of the household and his wife's devoted interests to his comfort and well-being were both his right and due, so accepted and commonplace as to be not worth commenting on. On the other hand in the more numerous pictures of odalisques being caressed or cuddled the relationship between the couples is seen as more suggestive and illicit that of lover and mistress.

One occasionally sees scenes of men pressing their attentions on women, such as in a picture by Rudolf Ernst, where an old man kisses the accidentally-exposed shoulder of a woman selling fruit in the street. In William Holman Hunt's *A Street Scene in Cairo: the Lantern-maker's Courtship* (1854, City Museum and Art Gallery, Birmingham), a young woman fends off her fiancé who, with an air of prurient glee, attempts to lift her veil, although it was traditionally forbidden in the Muslim world for a man to see his bride's face before the wedding. When Lady Anne Blunt visited Nedi (Arabia) in 1878, her guide told her that he wished to marry a young woman whom he knew only from hearsay. "I could see that he was terribly in love, for with the Arabs, a very little goes a long way; and never being allowed to see young ladies, they

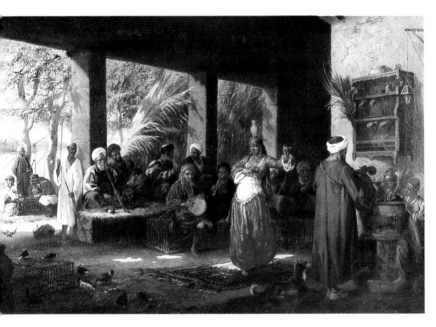

Alfred Darjou. *Gugglet Dance*, oil on canvas, signed, 20.50 x 30 in (52 x 76 cm). Private collection.

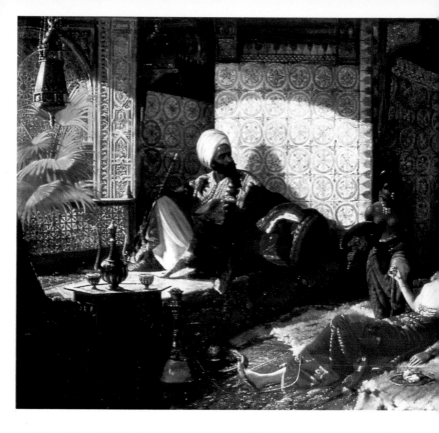

Vincent Stiepevitch. *The Favourite*, oil on canvas, signed and dated '86, 36.75 x 61 in (93.5 x 155 cm). Private collection.

fall in love merely through talking about them." Flirtation rather than courtship is the theme of a number of paintings, such as Etienne Dinet's *The Springtime of the Heart* (1904, Musée Saint-Denis, Rheims), where a young man holds down a woman's arms as he snatches a kiss; she only feigns resistance and laughingly accepts his embrace. In a painting by Jean-Léon Gérôme (1889, Arnot Art Gallery, Elmira, New York), an indecorously-forward woman on a balcony throws a rose to her admirer waiting on a horse below, a theme repeated by one of Gérôme's pupils, Paul-Marie Lenoir. In countries as far apart as Moorish Spain and

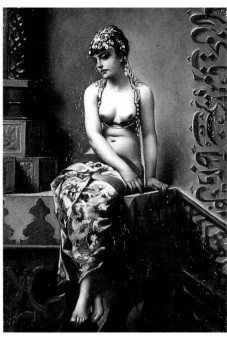

Luis Riccardo Falero. *The Bewitcher,* oil on canvas, signed and dated 1878, 11.75 x 9 in (30 x 23 cm). Private collection.

Kurdistan, it was the custom for women to communicate with their sweethearts by sending flowers, pomegranates or dried fruit, each token having its own significance. The great innovator Lady Mary Wortely Montagu is said to have popularised this form of communication on her return from Constantinople. In John Frederick Lewis's superb painting entitled *An Intercepted Correspondence, Cairo* (1869), the illicit love message is in the form of a bouquet. The symbolism of each flower would have been understood by his public, as a number of popular books on the subject had been published in mid-

Pages 130-131 :
John Frederick Lewis. *An Intercepted Correspondence, Cairo,* oil on panel, signed, 29.50 x 34.50 in (74.3 x 87.3 cm). Private collection.

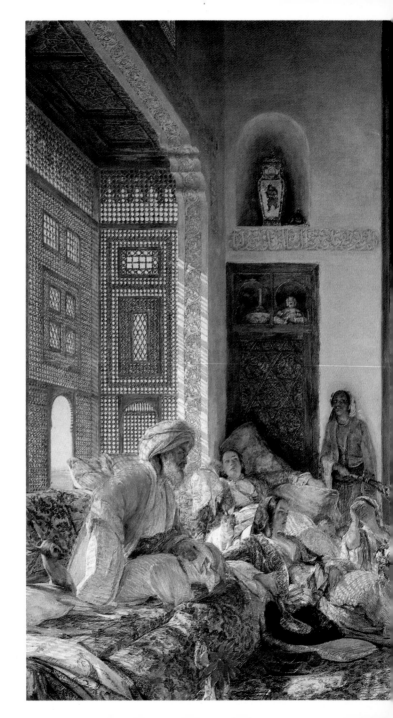

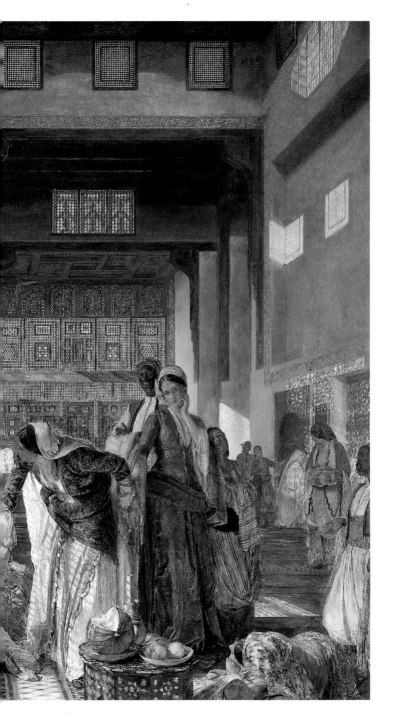

131

Victorian England. Not only that, there was a similar custom in Europe at the time; the different ways of holding a fan were accepted codes in the art of flirtation, to which every girl and young man held the key. Scenes of tender and romantic love were best portrayed by two artists who lived in North Africa for many years, Etienne Dinet and André Suréda. In several of Dinet's pictures, such as *The Quesba* or *Idyll* and *The Djouak*, lovers listen to

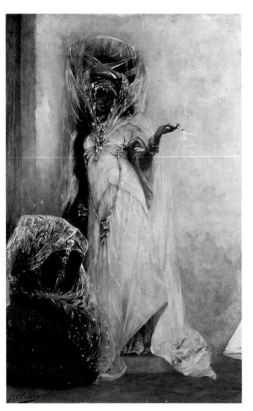

music played on a reed flute, just as they are doing in Suréda's painting illustrated here. In probably the most famous of all Dinet's paintings, *Slave of Love and Light of My Eyes* (1900, Musée d'Orsay, Paris), the young woman, held tightly in her lover's arms, puts her fingers across the man's mouth as he approaches to kiss her. In these works, the women are shy, but willing. On the other hand, in *The Courtesan* (1896, formerly in the Musée du Luxembourg, Paris), *The Enchantress* and *Love's Martyr*, Dinet shows Ouled-Naïl women sitting disdainful and haughty as men lie ogling them or grovel at their feet, devoured by desire. Georges Clairin also gives his Ouled-Naïl women an arrogant air, but he only depicted them alone or in groups, never with men.

Ghawâzi nomads, who were professional Egyptian dancers, are seen in a number of nineteenth-century paintings. Although by the 1850s, the name *almeh* was applied to them and, indeed, to all public entertainers, this word more correctly designated female improvisors of songs and poems. These dancers once used to perform in cafés and at private feasts in Cairo, but an 1834 edict issued by Mehemet (Mohammed) Ali had banished them to Keneh, Esna and Aswan. There, they became something of a tourist attraction. When Gustave Flaubert visited Esna in 1850, he was entertained by the courtesan Kuschiuk Hanem, who did a famous and alluring striptease

Georges Clairin. *Two Ouled-Naïl Women,* oil on canvas, signed, 31.50 x 35.75 in (80 x 60 cm). Félix Marcilhac collection, Paris.

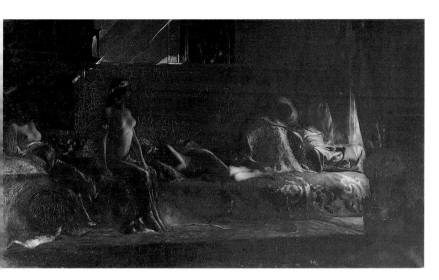

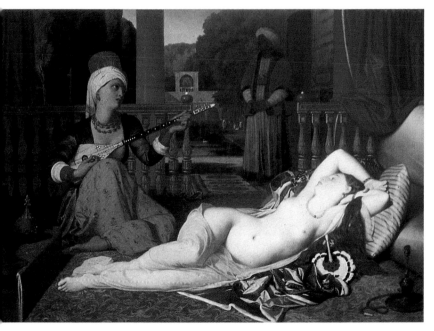

Benjamin-Constant. *The Sharifas,* oil
on canvas, signed, 45 x 76.75 in
(114 x 195 cm). Musée des
Beaux-Arts, Pau.

Jean-Auguste-Dominique Ingres. *Odalisque
with Slave,* oil on fabric, signed and dated
1842, 30 x 41.50 in (76 x 105.4 cm).
Walters Art Gallery, Baltimore.

dance known as the bee. It was so sensual, Flaubert recounts, that the youths playing the accompanying music had their eyes bound with handkerchiefs so that their innocence should not be corrupted. To the Egyptians of ancient as well as modern times, it was quite normal for the sexual act to be sublimated in a dance. On the other hand, the extremely conservative Egyptian society must have found many things about Europeans, their impiety, their acceptance of adultery, both vulgar and vile. Once again, it was a question of customs and taboos differing from one civilization to another. Many Western travellers felt ashamed, or affected to feel guilty, over finding the extremely varied Egyptian dances so thrillingly provocative, but predictably, paintings of women dancing for men's pleasure enjoyed great success in Europe.

Appreciative male onlookers are also depicted in Théodore Chassériau's *Handkerchief Dance* (1849, Musée du Louvre, Paris), in which the women seem to be moving as if in a trance. Théophile Gautier, who visited Algeria in 1845, one year before Chassériau, described a similar performance, as follows: "Moorish dancing consists in perpetual undulations of the body: twistings of the lower back, swayings of the hips, movements of the arms, hands waving handkerchiefs, languid facial expressions, eyelids fluttering, eyes flashing or swooning, nostrils quivering, lips parted, bosoms

André Suréda. *Idyll,* oil on paper laid down on cardboard, signed, 25.50 x 19 in (64.5 x 48 cm). Private collection.

heaving, necks bent like the throats of love-sick doves... all these explicity betoken the mysterious drama of voluptuousness of which all this dancing is the symbol." In another dance, the *guedra*, performed above all in Goulimine, a kneeling girl flutters her separated fingers while miming desire and abandon to a group of men. The dances of the Ouled-Naïl women were painted by Eugène Girardet, Marguerite Tedeschi, (*Arab Festival*, 1913) and Etienne Dinet. In the latter's *Night Festival,* painted in Laghouat in 1891 and *Group of*

Léon Cauvy. *Abundance,* gouache on paper, signed and dated 1920, 17.75 x 21 in (45 x 53.5 cm). Private collection.

Maurice Bompard. *Waiting*, oil on panel, signed, 21 x 25.50 in (53 x 65 cm). Private collection.

Spectators in a Dancers' Café (1905), the avid male spectators are engrossed in the spectacle, for the dancers' gestures and movements, although ritual and formal, were still sexually explicit: this entertainment was, after all, designed to tempt and seduce.

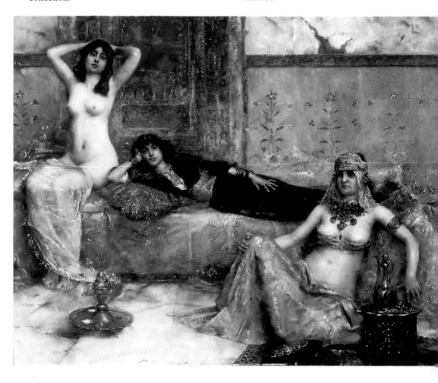

Hippolyte Lazerges. *The Love Token*, oil on panel, signed, 24 x 17 in (61 x 43 cm). Courtesy of the Mathaf Gallery, London.

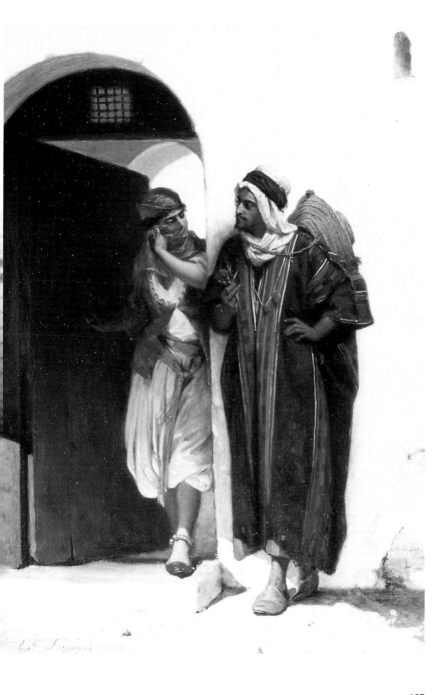

137

Everyday life

*C*amel caravans have always been part of the stock imagery of the Eastern world; hence, they often appear in Orientalist paintings. No one would have dreamed of travelling alone across the desert wastes, and months would sometimes go by before a large caravan could be formed and the long procession of people and laden camels, mules and donkeys finally set off. Many artists of the first half of the nineteenth century, such as

Léon Cauvy. *On the Wharf: the Admiralty of Algiers,* oil on canvas, signed and dated '17, 14.25 x 28.25 in (36.5 x 72 cm). Private collection.

Théodore Frère, John Frederick Lewis, Edward Lear, Richard Beavis, Honoré Boze, Narcisse Berchère and David Roberts, painted caravans that were led only by men, usually armed against surprise attacks from raiders. However, since the distances covered were prodigious and journeys would take many months, traders, in continual search of profitable markets, would

often take with them their wives, children and slaves. Indeed, certain paintings by John Austin Benwell, who made a speciality of caravans headed by a white camel in Egypt or the Sinai desert, show the travellers accompanied by women seated in *bassours*. Richard Dadd, in his 1843 *Caravan Halted by the Sea Shore,* situated in Syria, and Leopold Carl Müller, in his 1874 *Encampment in the Desert at Gizah* depict women busying themselves with water jugs

greeted by their friends beside a lake outside Cairo. One woman, however, sits grieving for her husband, lost during the long journey. Caravans were indeed often beset by unpredictable hazards, such as drought, floods and sickness. In *The Simoon – Recollection of Syria* (1847, Musées Royaux des Beaux-Arts, Brussels), by Jean Portaels, travellers, under suddenly darkened skies, attempt to shelter from the approaching sandstorm driven by a

while their menfolk rest. Pictures of women taking part in the great annual pilgrimage, or *hadj*, to Mecca are rare, and in Léon Belly's famous painting of *Pilgrims Going to Mecca* (1861, Musée d'Orsay, Paris), there is only one woman, riding on a donkey. However, several women are to be seen, in a watercolour by Henry Warren, *The Return from Mecca,* in which the travellers are

Gustave Lino. *Moorish Woman, Port of Algiers,* oil on panel, signed, 18.50 x 30.75 in (47 x 78 cm). Arts and Antiques, Riyadh.

hot, suffocating wind. On the other hand, women are often represented in paintings from the 1870s of nomad caravans, composed of one or more families. In a large painting by Eugène Girardet, dated 1877-78, camels and donkeys are loaded with tents and provisions, while men, women and children, riding or on foot, drive their herd of goats before them. The Swiss explorer John Louis Burckhardt, returning from Palmyra to Damascus in 1821, witnessed several similarly impressive caravans – which he described as strolling villages – advancing *en masse* over the sandy plain in search of water and pasture. Gustave Guillaumet, in his 1880 picture *In the Dunes* or *The Palanquin*, shows a young woman walking alone beside a camel bedecked with dangling trappings and surmounted by a *bassour*. Behind her, a long line of stragglers stretches out across the desert. Smaller tribes on the move were favourite themes of Victor Huguet, Emile Boivin, Paul Lazerges, Philippe Pavy and Alexis and Eugène Delahogue. The campsites chosen were often impressive. In an 1896 watercolour, Henry Andrew Harper painted the crags of Mount Sinai towering over the nomads' tents, while Paul-Elie Dubois often depicted Touareg encampments at the foot of the fantastic rock formations found in the Hoggar. Armand Point, Alcide Bariteau, Adam Styka and Eugène Girardet were amongst many artists who did pictures of encampments where women prepare, food or wash clothes in a nearby *wadi*. In a remarkable painting by Eugène Girardet dated 1880, a small family of nomads near Biskra have spread out their few possessions. Just as in

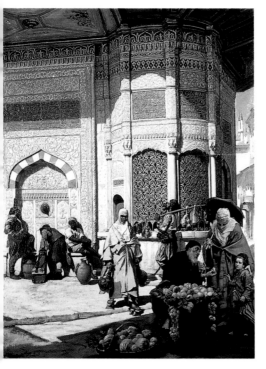

Hippolyte Berteaux. *Fountain in Constantinople,* oil on canvas, signed and dated 1872, 48.50 x 36.50 in (133 x 100 cm). Courtesy of Alain Lesieutre, Paris.

fixed abodes, one of the tents would be reserved for the women's harem quarters.

Besides these tribal scenes, a favourite theme in the mid-nineteenth century was that of Egyptian fellah women with a child on one shoulder, securely supported by the mother's upraised arm. A typical picture is Léon Bonnat's *An Egyptian Peasant Woman and her Child* (1870, Metropolitan Museum of Art, New York).

Although contemporary critics praised the artist's portrayal of the woman's ethnic characteristics, she is as majestically posed as those seen in Frederick Goodall's *The Palm Offering* (1875), Emile Vernet-Lecomte's *Fellah Woman* (1872, Stuart Pivar Collection, New York) and the Polish artist Elisabeth

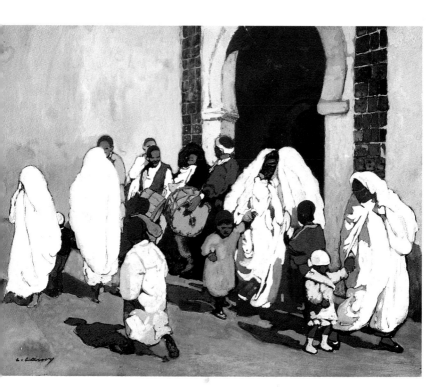

Léon Cauvy. *The Outing, Algiers,* gouache, signed, 13 x 16.25 in (33 x 41 cm). Private collection.

Jerichau Baumann's 1870 picture, *Memphis*.

Scenes painted in the Maghreb of mothers or elder daughters looking after children are more intimate. One of the earliest of these is Théodore Chassériau's *Two Young Constantine Jewish Women Rocking a Child* (1851, Mr. and Mrs. Joseph M. Tanenbaum Collection, Toronto). Here, the baby sleeps in a wooden cradle suspended by cords from the ceiling of a simple room. In *Young Woman Rocking an Infant in a Cradle* (1888), by Etienne Dinet, a hammock is slung outside a house in the oasis town of Bou-Saâda. Dinet treated a similar subject in 1909-10, *Girls in Bou-Saâda Carrying an Infant in a Basket*. In pictures by Edouard Verschaffelt, also painted in Bou-Saâda, and in Paul-Elie Dubois' portrait of the family of the Targuia called Tinguelouz, seated mothers hold their babies in their laps. In many other works, notably those by Gustave Guillaumet and Marie-Aimée Lucas-Robiquet, small children sit quietly as they watch the women of the family at their household tasks. They are also often seen being carried on their mothers' backs in the traditional North African manner, such as in Marius de Buzon's 1923 picture entitled *Kabyle Pastorale*. During the 1930s, artists working in the Maghreb, such as André Hambourg, Roger Nivelt, Christian Caillard, Roger Bezombes, Roger Limouse and Edouard Edy-Legrand, painted family groups in which the man is present as head of the household. There are, however, no innuendoes concerning his relationship with the women around him, as in the earlier fantasy harem paintings.

For many Eastern women, everyday life was far removed from the frivolous activities and light tasks of the cossetted women in large harems. Although much more

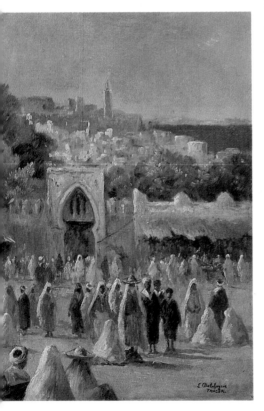

Eugène Delahogue. *Marketplace in Tangiers*, oil on canvas, signed and inscribed Tanger, 13 x 9.50 in (33 x 24 cm). Courtesy of Jacques Fricker.

independent, they had to work hard to keep their families fed and clothed, particularly in country regions where living conditions were harsh. Children learned work skills very young and were more than just a token help to their elders. Responsibility was assumed at an early age. Small girls, often carrying the family's latest baby on their backs, would not only take part in the domestic tasks but also learn home crafts. These scenes, often represented on postcards, were painted above all by artists in North Africa. A 1903 picture by Vincent Manago (Musée des Beaux-Arts, Marseilles) of an Algerian woman kneading dough outside her house was, in fact, painted from a postcard. In other pictures by Alfred Chataud, J. Alsina, Henry d'Estienne and

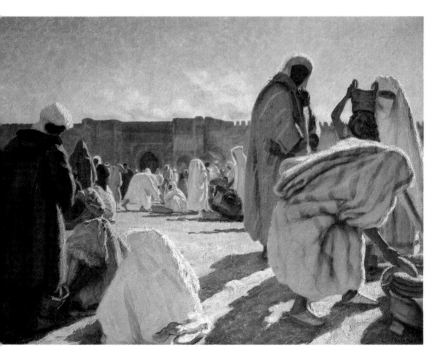

Camille Boiry. *Moroccan Market,* oil on canvas, signed, 45.75 x 59.50 in (116 x 151 cm). Musée des Beaux-Arts, Tours.

Alexandre Roubtzoff, young girls or women sit on the ground holding a dish between their outspread legs as they roll semolina for couscous. Flour was ground at home in much the same position, the small roughly-formed millstones being turned by a vertical wooden handle. Etienne Billet, though, painted women carrying baskets of wheat to the

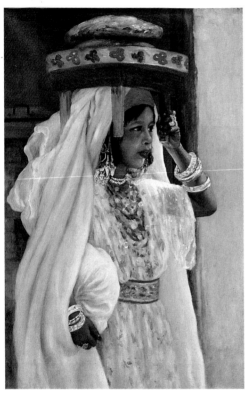

Henry d'Estienne. *Arab Girl Carrying Bread,* oil on canvas, signed, 27.25 x 18.25 in (69 x 46 cm). Private collection.

miller (Musée Duplessis, Carpentras), while in a picture by Antoine Gadan, a woman and her children wait to collect flat loaves of bread which a baker has just pulled out of an oven and which lie cooling on the ground. Clothing, particularly burnouses and *haïks*, and, in some regions, carpets, usually kelims, were woven on primitive looms at home. The sight of the preparatory carding of the fleece and the delicate task of teasing out the threads from a distaff held in the woman's upraised hand particularly attracted such artists as Charles Landelle, Alexandre Masson, Louis-Auguste Girardot, Maurice Bompard, Hippolyte Lazerges, Jules Taupin and Lucien Lévy-Dhurmer. In *The Weavers*, by Gustave Guillaumet (Musée d'Orsay, Paris), typical of his series of paintings on this subject, a woman sits on the stairs of a humble Saharan house while two others work the loom. A third pushes down and straightens the weft threads with a comb. The same museum owns an 1889 picture by Paul Leroy entitled *Weaver in Biskra*, which shows a woman working alone, as in his *Weaver Under a Tent, Biskra* (1930). Other scenes of women weaving in Algeria or Tunisia were recorded by Eugène and Alexis Delahogue, Marie-Aimée Lucas-Robiquet and Alexandre Roubtzoff. Knotted pile carpets were generally made in special workshops where children were often employed, since their nimble fingers were better suited to this work than those of adults. Moreover, schools in North Africa were created to encourage local crafts such as leatherwork and embroidery. The fetching of water for the family was

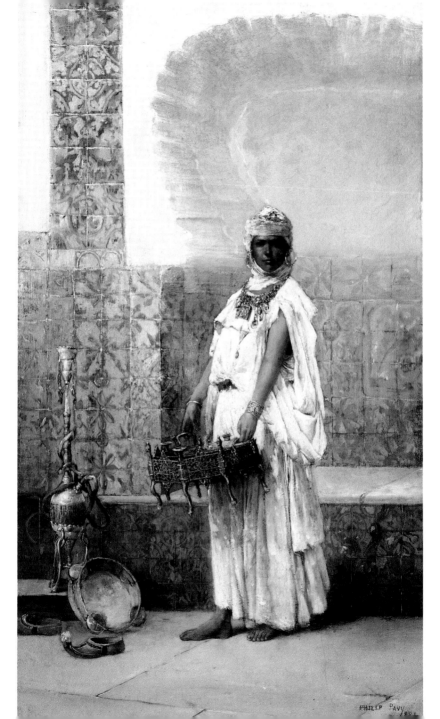

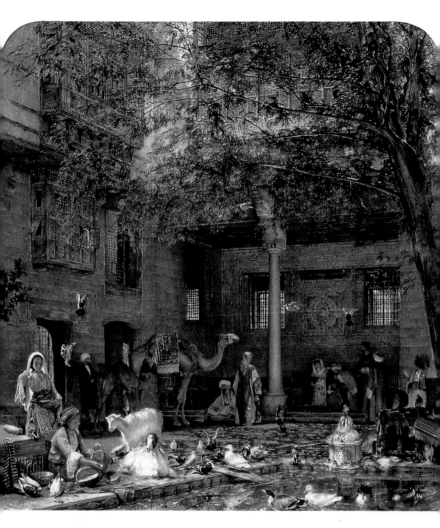

John Frederick Lewis. *The Hósh (Courtyard) of the House of the Coptic Patriarch, Cairo*, oil on panel, 14.50 x 14 in (36.8 x 35.5 cm). Tate Gallery, London.

Page 145 :
Philippe Pavy. *The Serving Girl,* oil on panel, signed and dated 1882, 23.25 x 13.25 in (59 x 32.5 cm). Courtesy of the Mathaf Gallery, London.

naturally an essential task, one that was particularly arduous in arid regions. In cities, the watersellers, with their goatskins and brass cups, were familiar figures in the streets. Both they and the *sebils*, or public fountains, in Constantinople and Cairo were frequently painted by the Orientalists. These *sebils* were often donated as an act of piety by wealthy citizens, the providing of water being regarded as a particularly meritorious act. The Ahmed III fountain in Constantinople was the most elaborate, with niches, intricate ironwork, columns, coloured faience tiles and a pagoda-shaped roof.

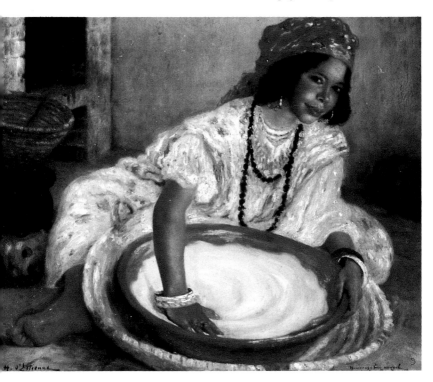

Henry d'Estienne. *Preparing Couscous,* oil on canvas, signed and dedicated to Mlle Armelle Pinoult, 16.75 x 20 in (42.5 x 50.5 cm). Private collection.

Amadeo Prezosi painted this fountain, and also a more modest one in front of which stand women and their children. In this watercolour, one woman pulls down her veil in order to drink from a goblet. *Sebils* also served as community gathering places where people could exchange news and gossip; such moments were recorded by Georg Emanuel Opiz, Pascal Coste, Louis Mouchot and Fabius Brest. In Gustav Bauernfeind's 1887 *Jaffa Market*, women holding jars patiently await their turn while the bustling activity of the marketplace goes on around them.

For a number of Orientalists, the fetching of water took on a deeper significance. These artists, convinced that life and habits were unchanged in the timeless Eastern world, were only too ready to see living images of Bible stories. Horace Vernet was the first artist to paint Old Testament scenes featuring local ethnic types and dress; up until then, biblical figures had been represented with Western faces and vaguely classical clothes. One of the earliest of these was his *Rebecca at the Fountain* (1834), which he was inspired to paint after seeing an Arab girl giving a man a drink at a well. An extreme example is James Tissot. After becoming fervently religious, he made three trips to the Holy Land to steep himself in ancient customs and traditions. He made countless sketches and did historical research in order to produce painstakingly authentic illustrations for the Old and New Testaments. In two of these, *Abraham's Servant Meeteth Rebecca* (circa 1889-1901, The Jewish Museum, New York) and *The Sojourn in Egypt* (circa 1886-94, National Gallery of Ireland, Dublin), an oil replica of the gouache illustration, a line of women carry on their heads water jars poised on special small pads. Fellah women drawing water from the Nile were a common sight. Although not all artists made such direct scriptural references, their paintings of these women, with their unusually erect posture, balancing narrow-necked

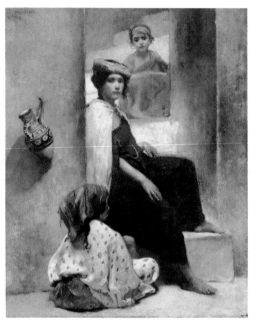

Paul Leroy. *Woman and Children in a Saharian Interior, Algeria*, oil on panel, signed in French and Arabic, 15.75 x 12.75 in (40 x 32.5 cm). Private collection.

jugs on their upturned palms, carrying heavy jars on their heads, or else leaning forward to fill the container, emphasised the antique nature of this task. Amongst the many authors of this type of picture, which was generally in cool tones of blue, turquoise, green, brown and grey, were Charles Landelle, Hans Makart, Narcisse Berchère, Félix Clément, Eugène Girardet, Charles-François Jalabert, Frederick Goodall, Jean-Léon Gérôme and Théodore Frère. Léon Belly, visiting Egypt in 1850-51, was struck by the elegance of a group of fellah women. He noted that "They possess native gracefulness, nobleness of gesture and perfect balance in all their movements, as well as an easiness that quite possibly comes from their continuously engaging in the exercise of carrying large amphorae." He got the women to

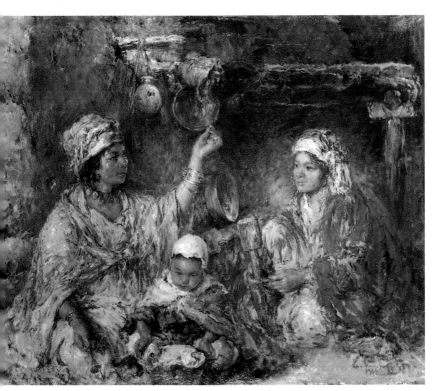

Edouard Verschaffelt. *Family Scene,* oil on canvas, signed and dated 1948, 29 x 35 in (74 x 89 cm). Private collection.

repeat the same movement over and over while he made dozens of sketches. The resulting painting, *Fellah Women on the Banks of the Nile*, was exhibited at the 1863 Salon in Paris. The same gracious gestures are visible in the highly stylised Egyptian paintings of the 1890s by Emile Bernard and in Kees van Dongen's *Fellah Women* or *In Egypt,* of 1913.

Another picture in the same vein, this time situated in Algeria, is Paul Cirou's *Kabyle Women Carrying Water* (Musée National des Arts d'Afrique et d'Océanie, Paris). Here stately, barefooted women in flowing red robes bend under the weight of the large, painted amphorae they carry on their backs. In 1922, Marius de Buzon painted a similar work, *Kabyle Canephorae.* In general, however, pictures of North African women drawing or carrying water are very different from those set in Egypt. Not only are they in warm tones of orange, red, ochre, off-white and green, but the womens' postures, as they squat in rocky *wadi* beds or lean over pools, are more prosaic. Although their gestures are as traditional as those of Egyptians, there are no sriptural or classical references. In *Un été dans le Sahara* (1856), Eugène Fromentin describes one of these scenes, as follows: "The women and children are there, bending over the dark water, their backs in the sunlight, *haïks* tucked up above their knees, veils tied back filling and emptying dippers, funnelling the water into the bulging goatskin bottles that they proceed to tie tightly. All of them are bustling about, exerting themselves, actively attending to the task at hand, but exchanging so few words that the casual onlooker might think them to be mute. The water that is being poured exudes an atmosphere of seeming coolness, and until nightfall, the wet dust gives off the deceptive odour of a rainstorm." Probably one of the best-known pictures on the theme of water is Gustave Guillaumet's *The Seguia, near Biskra* (1884, Musée d'Orsay, Paris), for which the artist made many preparatory landscape- and

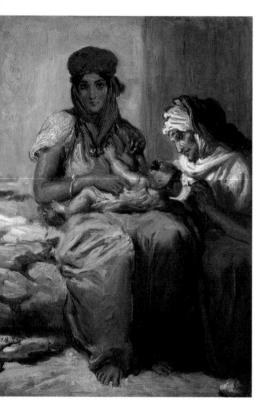

Théodore Chassériau. *Moorish Woman Nursing her Infant, and an Old Woman,* oil on panel, signed and dated 1850, 8.75 x 6.25 in (22 x 16 cm). Musée du Louvre, Paris (on loan to the Musée des Beaux-Arts, Poitiers).

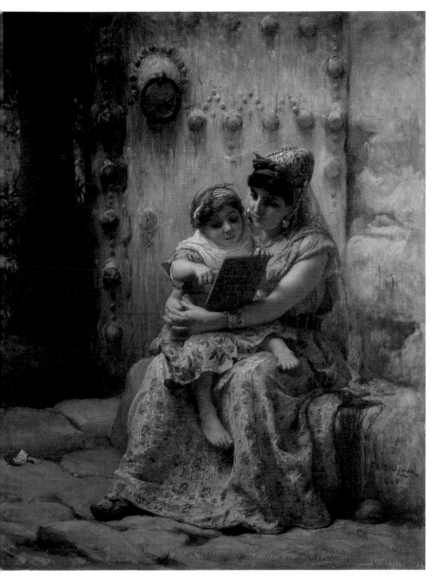

Frederick Arthur Bridgman. *The Reading Lesson,* oil on canvas, signed and dated 1880, 42.50 x 34 in (108 x 86.4 cm). Private collection.

figure studies. Several of the artists who depicted water-fetching also painted women laundering out of doors, usually in El-Kantara, Laghouat, Bou-Saâda or Gabès. The washerwomen alternately rinse the cloth and beat it clean on a rock, wring it out and then spread it to dry in the sun in the universal traditional rural manner. These paintings are usually very similar in treatment, although Robert Génicot's 1931 *Morocco: The Washerwomen* has such vigour and force that the normally peaceful everyday scene is transformed into one of exciting energy.

Busy street scenes in which women are seen shopping or selling their wares enjoy a major place in the Orientalist repertoire. In the 1880s and 1890s, Gustav Bauernfeind did some highly detailed pictures of the old part of the city of Jaffa before the walls and gateways were pulled down. In these, as in his views of Jerusalem and Damascus, he shows the various activities of the people, but also emphasises the crumbling houses and rough paving stones. Alberto Pasini, on the other hand, embellished his marketplaces, whether situated in Damascus or Asia Minor. Women wearing attractive, brightly-coloured clothes move amongst horsemen and passers-by in the sunlight and there are often trees in full leaf. His *Constantinople, a Street in Galata* shows part of the city's tumultuous commercial quarter on the port. In another work, by Hermann Corrodi, an endless stream of people cross the Galata bridge, which linked Pera – where most Europeans lived – and the Turkish Stamboul. Women carry baskets or babies, three of them pausing to rest on the pavement as the sun sets behing the mosque. Dozens of nineteenth-century artists of all nationalities in Turkey and Egypt evoked all the atmosphere of Near Eastern marketplaces and bazaars. The people in many of their paintings are seen merely as part of a crowd; their gestures and activities are carefully studied, but the personality of each individual is not

Lucien Lévy-Dhurmer. *Moroccan Woman Spinning,* oil on canvas, signed, 26.75 x 19.75 in (68 x 50 cm). Private collection.

always brought out. On the other hand, women street vendors are often painted in close-up as they sell piles of oranges or bread, notably in works by Alberto Rosati, Henry Wallis, Philippe Pavy, Frederick Arthur Bridgman and Emile Bernard. Although these women were generally unveiled, the features of the young woman vendor in Leopold Carl Müller's *Marketplace*

outside Cairo (1878, Österreichische Galerie, Vienna) are hidden by the narrow black *burgo* worn by many Cairene women, which reached from under the eyes nearly to the ground. She leans forward in an elegant manner; even when heavily-veiled, Egyptian women had ways of showing their beauty, by a turn of the wrist, a certain gait, a slender silhouette or the gracefully arranged

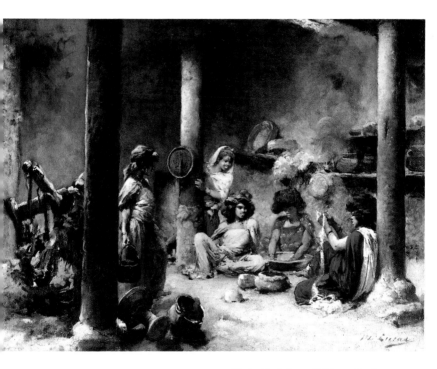

Marie-Aimée Lucas-Robiquet. *Southern Algerian Interior*, oil on canvas, signed, 18 x 20.50 in (46 x 52.2 cm). Private collection.

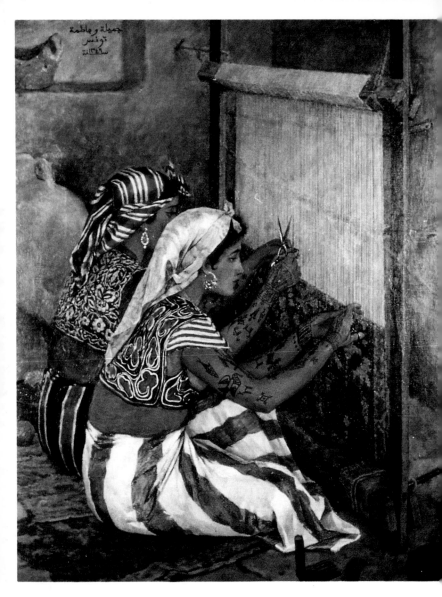

Alexandre Roubtzoff. *Djamilla and Fatima,*
oil on canvas, signed and dated Tunis
1931, inscribed and dated in Arabic,
53.50 x 43.25 in (136 x 110 cm).
Private collection.

folds of their cloaks.

Artists working in the Maghreb – Alphonse Birck, Emile Pinchart, Pierre Vignal and Fernand Lantoine, for example – depicted women slipping silently through the narrow cool casbah alleyways, which give no hint of the richly-decorated houses hidden behind the blind walls and solid doorways. In Maurice Denis's unusual picture entitled *Constantine* (National Museum of Western Art, Tokyo), the tiny figures of women in a cobbled street are dominated by the intricately imbricated houses typical of most casbahs. In pictures by Aloysius O'Kelly and Rubens Santoro, three Algiers women walk briskly along. The folds of their full white trousers and *haïks* are sharply delineated in the brilliant sunlight. It was the whiteness of Algiers that struck Jean Seignemartin, who, like a number of other Orientalists, sojourned in North Africa in the vain hope that the warm climate would cure his poor health. In his picture entitled *Street in Algiers* (1875, Musée des Beaux-Arts, Lyons), he gives a general impression of light and movement rather than any detail. Women are conspicuously present in paintings of the Maison-Carrée market near Algiers by Léon Cauvy and Yvonne Kleiss-Herzig. Other early twentieth-century artists, such as Marius de Buzon, Jean Bascoulès, Maurice Bouviolle, Henri Chevalier and Gaston Balande, show women in the crowds on the Place du Gouvernement in Algiers or in the Mozabite town of Ghardaïa. Like Yvonne Mariotte's *Market in Fez* (1937, Musée National des Arts d'Afrique et d'Océanie, Paris), these pictures are seen from a bird's-eye viewpoint, a noteworthy feature in North African painting of the 1920s and 1930s. The great crowd in Tangiers' Grand Socco in a remarkable 1880 painting by Frank Buchser (Gottfried-Keller-Stiftung,

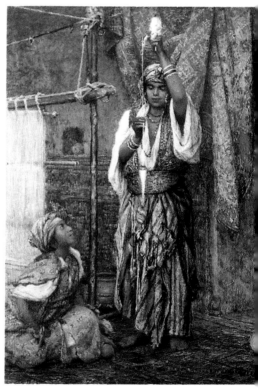

Louis-Auguste Girardot. *Spinning,* oil on hardboard, signed, 14.25 x 11 in (36 x 28 cm). Courtesy of the Gallery Keops, Geneva.

155

Berne) is reminiscent of similar scenes painted in Egypt at the same period. On the other hand, pictures of Moroccan souks, particularly those of the 1920s, are highly stylised, notably those done in Marrakesh by Jacques Simon, Marcelle Ackein and Jacques Majorelle, as well as in Bernard Boutet de Monvel's striking portrayals of women waiting patiently in the sun to sell carpets, peppers, pottery or oranges. In the series of pen- and wash drawings by Lucien Lévy-Dhurmer, Moroccan women vendors are seen sitting in rows; in Camille Boiry's *Moroccan Market* (1922, Musée des Beaux-Arts, Tours), a woman bends straight from the waist to pick up a loaf of

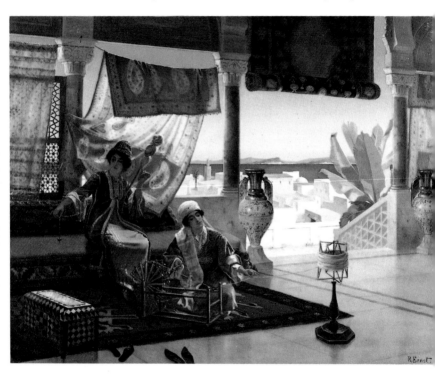

Rudolf Ernst. *Women Spinning, Morocco,* oil on panel, signed, 31.50 x 36.50 in (80 x 100 cm). Private collection.

bread. This movement, so often seen in North African paintings and particularly frequently in works by Léon Cauvy, is practically never found in representations of Egyptian or Turkish women.

Fruit was one of the Maghreb's natural riches and scenes of fruit-picking often figured in early twentieth-century postcards. They were even more common in photographs illustrating periodicals or books published at the time concerning the economy of France's North African possessions. On the other hand, these scenes were rarely painted, perhaps because they smacked too much of agricultural statistics or advertising. There are a few exceptions, such as Marius de

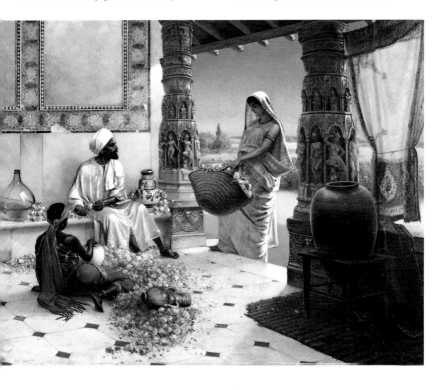

Rudolf Ernst. *Gathering Roses,* oil on panel, signed, 28 x 36.25 in (71 x 92 cm). Courtesy of the Gallery Keops, Geneva.

Buzon's *Grape Gathering in Kabylia,* painted in 1927, in which women carry baskets of grapes that boys have just picked from climbing vines. Several other artists, including Eugène Girardet, Marie-Aimée Lucas-Robiquet and Maurice Bompard, showed dates being picked or transported on donkeyback, but in general artists were content just to paint the immense palm groves that surrounded oasis towns in the south. There is, however, a magnificent series of pictures dating from the 1930s by Jacques Majorelle, in which Moroccan women carry bunches of bananas or dates. In these, the silver or gold grounds and the luxuriant foliage set off the splendid naked bodies of his black models whom he posed in the exotic garden of his villa in Marrakesh.

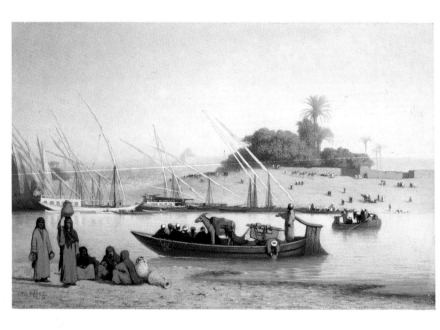

Théodore Frère. *Old Cairo,* oil on panel, signed, 10.50 x 16 in (26.5 x 40.5 cm). Courtesy of the Mathaf Gallery, London.

William Holman Hunt. *The Afterglow in Egypt,* oil on canvas, signed with monogram, 32.25 x 15 in (82 x 38 cm). Ashmolean Museum, Oxford.

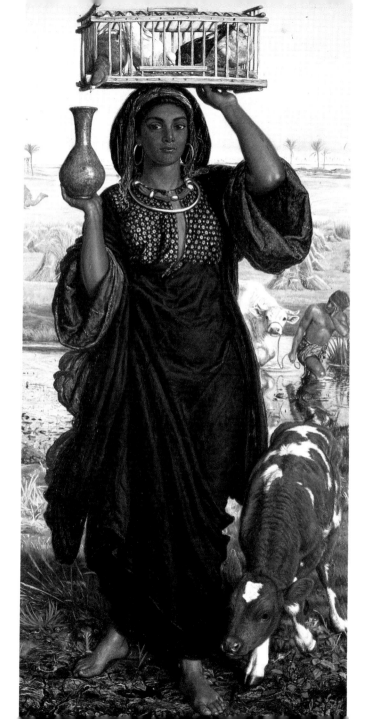

159

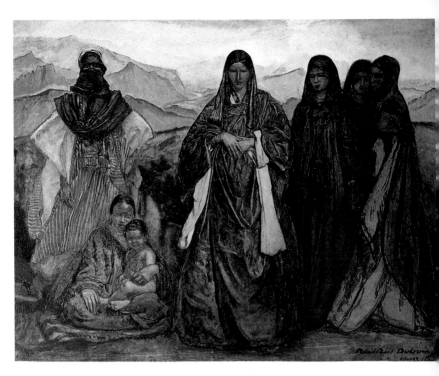

Paul-Elie Dubois. *Tinguelouz's Family in
the Hoggar* or *Tinguelouz, Noble Woman,
in the Hoggar,* oil on panel, signed and
dated Hoggar '38, 43.25 x 57 in
(110 x 144 cm). Private collection.

Yvonne Kleiss-Herzig. *Returning from the
Market*, gouache, signed, 12.50 x 19.50 in
(31.5 x 49.5 cm). Private collection.

Jacques Majorelle. *Carpet Sellers, Souk el
Khemis, Marrakesh*, oil on canvas, signed
and inscribed Marrakech. Société Générale
Marocaine de Banques, Casablanca.

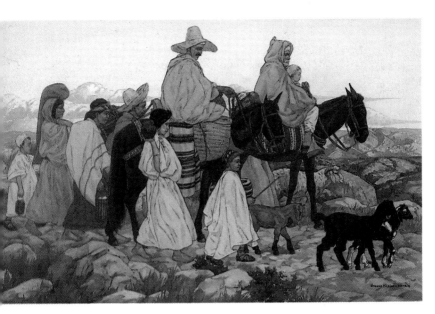

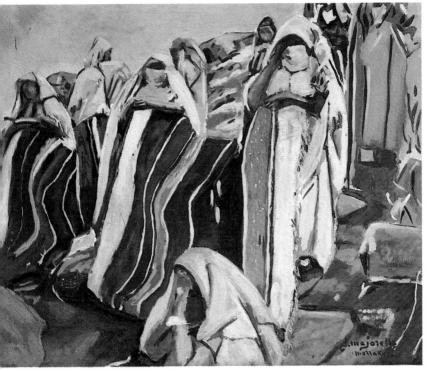

Tragedy

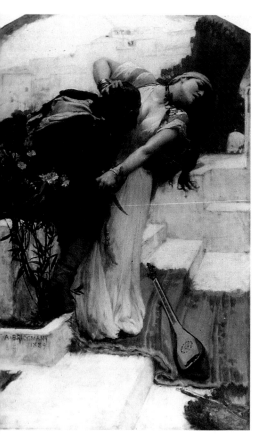

Frederick Arthur Bridgman. *The Pirate of Love,* oil on canvas, signed and dated 1889, 52.75 x 34.50 in (134 x 87.5 cm). Private collection.

*N*ineteenth-century Islamists made it quite clear that most Muslim women were perfectly free to come and go as they wished and that they were neither oppressed nor guarded, except for the inmates of the seraglio and other large Turkish harems. Not only that, women exercised considerable authority in they own homes. Many Westerners, though, remained firmly convinced that the condition of Muslim women was pitiable. A typically hysterical outburst comes from E.H. Mitchell in 1891; she declined to enter a harem, as she thought it was a place of degradation. "Were it possible that by such a visit to help our poor sisters out of their slavery, I should only have been too thankful to make it, but to go and see them penned up in their detestable prison was a good deal more than any Christian woman ought to bear." ("Forty days in the East," *The Academy,* London).

It was true, however, that the women in the large Osmanli harems were of slave origin. A few of these were Europeans captured by pirates, such as the legendary Aimée Dubucq de Rivery. This Creole from Martinique, a cousin of Josephine de Beauharnais, was seized in 1784 as she left her convent school in Nantes, taken to the dey of Algiers and then sent as a present to the sultan of Turkey. Using her position of great power as the *valide,* or queen mother, she became, it is said, the *éminence grise* behind the

Sublime Porte's foreign affairs. Her story is perhaps entirely real, but she could also be an amalgam of various Western captives. For the most part, the concubines in these harems were Georgians, Circassians or Armenians. The beauty of the Georgian women was proverbial and they were highly valued for their slender waists, long, shapely legs, magnificent eyes and hair. "As far as the Circassian women were concerned," notes N.M. Penzer, "they often went entirely of their own free will, being anxious to exchange a peasant life for the gamble of becoming a pasha's wife or maybe even the concubine of the sultan himself." After the Circassian people's heroic resistance to Russia, and their mass exodus in 1864 into Turkey, the Circassian slave-dealers were driven to carry on their nefarious trade nearer Constantinople, in Rumelia and on the Asiatic coast at Brusa. The girls

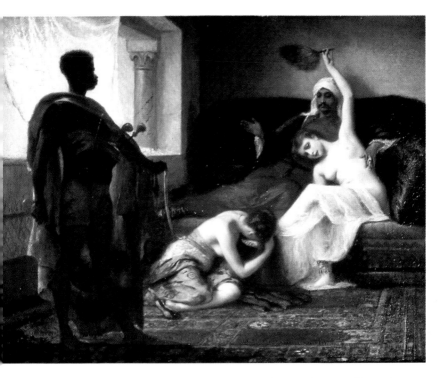

Fernand Cormon. *The Deposed Favourite,* oil on canvas, signed and dated '70, 21.50 x 25.50 in (54.50 x 64.8 cm). Private collection.

would sometimes be bought by traders who, after carefully training them, would later sell them to advantage. In spite of a law passed by the Turkish government in deference to Western opinion, the slave trade continued unabated, although not quite so openly as before. Total abolition of slavery would have meant the abolition of the system of large harems, and not until the deposition of Sultan Abd ul-Hamid II, in 1909, was the seraglio harem dispersed.

After learning the various arts of pleasing men, many of these Circassians would enter the harems of wealthy Turks in Egypt, where

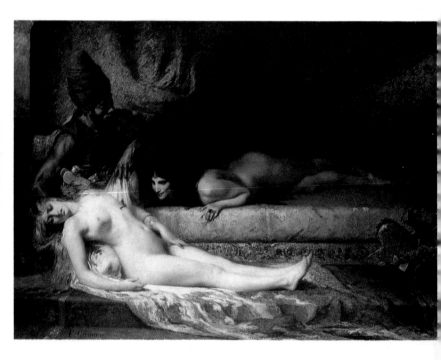

Fernand Cormon. *Jealousy in the Seraglio,* oil on canvas, signed and dated 1874, 63 x 86.75 in (160 x 220 cm). Musée des Beaux-Arts et d'Archéologie, Besançon.

they were richly dressed and, according to Edward Lane, indulged in every luxury. Less fortunate, and certainly more reluctant both to become concubines and to live in a Muslim household, were the Greek girls captured by Ibrahim Pasha's Turco-Egyptian armies. At the end of the Greek War of Independence, many of them refused to be

liberated, as they were too ashamed to return to their home country. While many black women became concubines of well-to-do Egyptians and bore them children (it is interesting to note that the Orientalists never painted black odalisques), the majority entered domestic service. Not only were

to the market, as a way of providing for them handsomely... but the blacks and the Abyssinians fight hard for their liberty." Although, like the Circassians, some black parents preferred their children to become slaves so that they might have a chance of better living conditions, many Abyssinians (or, more

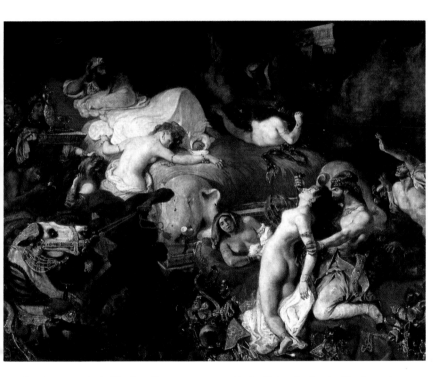

they better protected by law than spouses or concubines, but a large number of them were emancipated, since Muslims considered this a pious act. "What a folly it is to stop the Circassian slave trade, if it is stopped," wrote Lucie Duff Gordon in Egypt three years after the Russian victory in 1864. "The Circassians take their own children

Eugène Delacroix. *Death of Sardanapalus*, oil on canvas, signed, 154.25 x 195.25 in (392 x 496 cm). Musée du Louvre, Paris.

correctly, Ethiopians) and Sudanese were forcibly seized. They suffered greatly from the passage across the desert and the voyage down the Nile, when they were crammed like sardines into boats. Maxime du Camp described the *dahabeeyahs* he saw in 1849 returning from their long and painful journeys on the Upper Nile. Their human merchandise was installed in great *okels* (caravanserais) in Cairo where, he said, people would go to purchase a slave as they go in France to the market place to buy a turbot. Slave markets were in fact few in number; Alexandria and Cairo served as the main depots for the rest of the Eastern world. While the artist David Roberts found the Alexandrian market in 1838, where he saw young black women squatting in the burning sun, "a sickening sight," another painter,

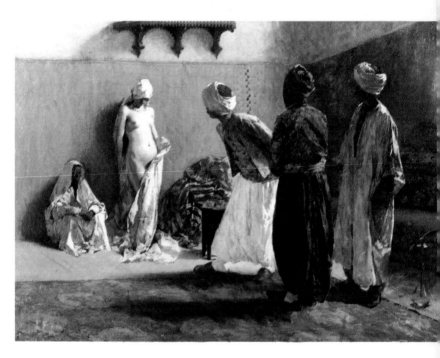

Ettore Cercone. *Examining Slaves,* oil on canvas, signed and dated '90, 21.25 x 30.50 in (54 x 77.3 cm). Private collection.

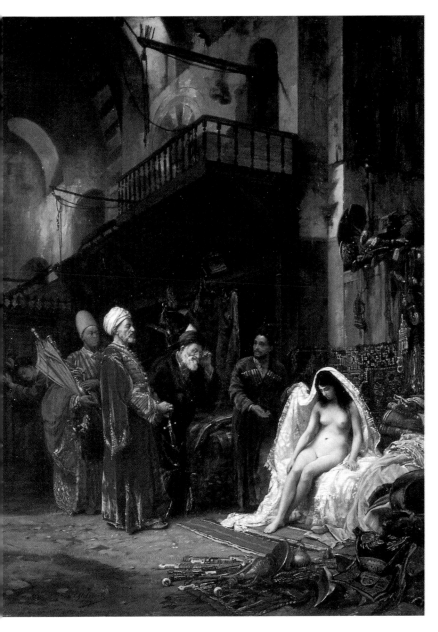

Stanislas von Chlebowski. *Purchasing a Slave, Constantinople,* oil on canvas, signed and dated 1879, 36.75 x 28.50 in (93 x 72 cm). Archives Berko Fine Paintings, Knokke-le-Zoute.

William James Muller, visiting Egypt that same year, admitted to being morbidly fascinated by the one in Cairo. Pictures show newly-captured slaves as abject, dejected or humiliated. Above all, women – particularly Circassians – are seen naked, for these purportedly true scenes gave artists an opportunity of painting nudes. What was more, Western society at the time was obsessed by the theme of female submissiveness and defencelessness, before the female emancipation movement had gathered strength. When the European countries, Britain in particular, were deeply engaged in the inordinately profitable slave trade, there had been many illustrations showing the horrors and brutality of the slaves' capture, transport across the Atlantic and exploitation in New World plantations. The Abolitionists made great use of these in their battle to win legislative reform, in order to attract public sympathy. But since slave-trading continued in Africa

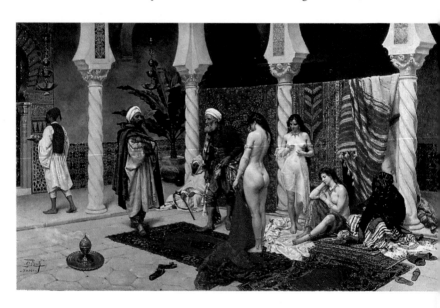

Giulio Rosati. *Inspecting the New Arrivals,* oil on canvas, signed and inscribed Roma, 24 x 39.50 in (61 x 104 cm). Private collection.

Horace Vernet. *Capture of Abd el Kader's Retinue by the Duc d'Aumale,* oil on canvas, signed with monogram, 53.25 x 34.75 in (135 x 88 cm). Private collection.

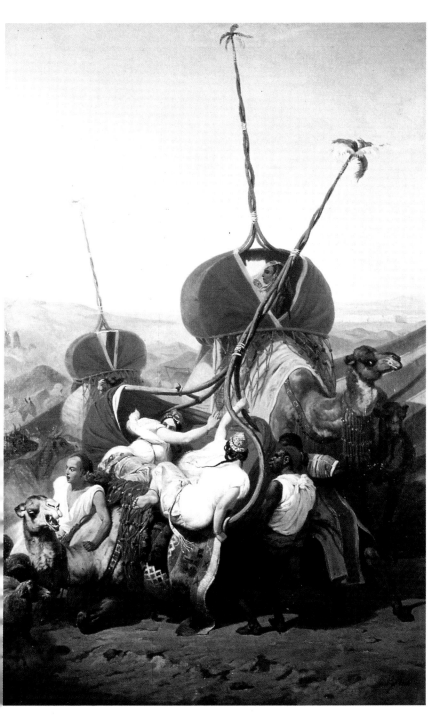

after emancipation had been accepted by Western countries, illustrators were again in demand, this time to show the civilising effect that colonising countries would have in Africa. However, it is highly unlikely that these nineteenth century academic paintings of slave markets (whether set in the Eastern world or in antique Rome) were intended as propaganda against the trade. They were too salacious to arouse indignation.

Pictures of women captured as spoils of war, set in ancient times, were prevalent in the nineteenth-century; for example, Georges Rochegrosse's *Huns pillaging a Gallo-Roman Villa* and Paul-Joseph Jamin's *Le Brenn and his Share of the Booty* (Musée des Beaux-Arts, La Rochelle), both shown at the 1893 Salon de la Société des Artistes Français. A similar historical scene – this time, Orientalist – was painted by Benjamin-Constant. *The Day After a Victory at the Alhambra, Moorish Spain, Fourteenth Century* (1882 Salon, Montreal Museum of Fine Arts) shows female captives in various states of abject misery. In Georges Clairin's *After Victory: the Moors in Spain* (1885, Musée des Beaux-Arts, Agen), stricken, half-naked women lie amongst the bodies of their slain men. In these, the theme is again domination and possession. Clairin's canvas is enormous, and like many illustrations intended for this chapter, it is too large to be successfully photographed. Not only that, drama and violence are not today considered "commercial" subjects; this type of picture is hence seen but rarely on the market, and the whereabouts of paintings illustrated in catalogues and books of the period are not now known.

Intrigues in the seraglio were a subject that captivated artists. From the moment that Roxelana, the legal wife of Soliman the Magnificent, obtained complete ascendancy over the sultan until her death in 1558, and for about a hundred and fifty years, the royal harem became a hotbed of bribery, extortion, plots and counterplots. Murders and mass executions were frequent. Later, the palace was often the scene of bitter rivalry between the *valide* (queen mother) and the four *kadins*, or favourites, who sought power for themselves and their sons; there were also concubines who aspired to

higher rank and who were ready to employ any means, fair or foul. The women were helped in their intrigues by the complicity of the black eunuchs and the *kislar agha*, or chief black eunuch, the most feared and the most bribed official in the whole of the Ottoman empire. Not surprisingly, these moments in the bloody history of the seraglio inspired a number of paintings.

Fernand Cormon, in *Jealousy in the* *Seraglio* (1874, Musée des Beaux-Arts et d'Archéologie, Besançon), shows the evil glee of an odalisque whose rival has been stabbed to death; in Stanislas von Chlebowski's *Strangling of a Sultana* (1876), a black eunuch creeps into a room where a sultana and her attendants lie sleeping. He makes a sign to the strangler waiting in the doorway.

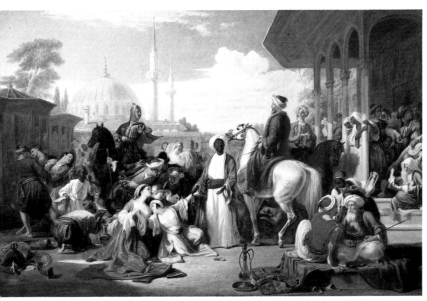

Sir William Allan. *Slave Market in Constantinople,* oil on panel, 50 x 76 in (127 x 193 cm). Courtesy of The Fine Art Society, London.

Drama in the Harem (1908), by Théodore Ralli, portrays a favourite who is driven to madness by the sight of the sprawling body of her poisoned victim. Not all crimes were perpetrated by jealous women. Artists showed treacherous women being assassinated on the ruler's orders, as in Benjamin-Constant's *The Sheriff's Justice* (1885, Musée d'Orsay, Paris, on loan to the Musée de Lunéville). In Paul-Léon

Bouchard's *The Mutes of the Seraglio*, black eunuchs enter the harem to execute the women, who shrink back in fear. These melodramatic pictures were all by academic Salon painters; the realist artists of the late-nineteenth- and early-twentieth century preferred to show more insidious evils: famine, drought and the suffering of desert tribes. One of the most terrible of these scenes is Jules van

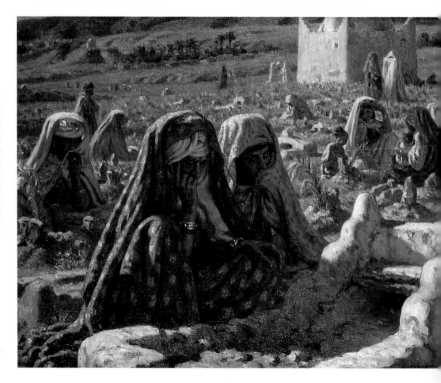

Etienne Dinet. *Friday in the Cemetery,* oil on canvas, signed, 39.25 x 32 in (100 x 81 cm). Private collection.

Biesbroeck's *Nomad Family* (1930), in which the effects of poverty and harsh living conditions are written on the faces of the mother and her young children. Other artists treated the theme of repudiation and banishment: Camille Corot, *Hagar*

in the Wilderness (1835, Metropolian Museum, New York); Horace Vernet, *Hagar cast out by Abraham* (1837, Musée des Beaux-Arts, Nantes); and Jean-Charles Cazin, *Hagar and Ishmael* (1880, Musée des Beaux-Arts, Tours). In Gustave Boulanger's 1871 painting of the same scene (Stuart Pivar Collection), the two outcasts are portrayed as Algerian nomads, the striped tents of their tribe in the background. In a contemporary Muslim rather than a biblical context are Etienne Dinet's *The Repudiated Wife* and *The Abandoned Wife* (1921, Musée National des Beaux-Arts, Algiers, on loan to the Palais de la Présidence, Algiers).

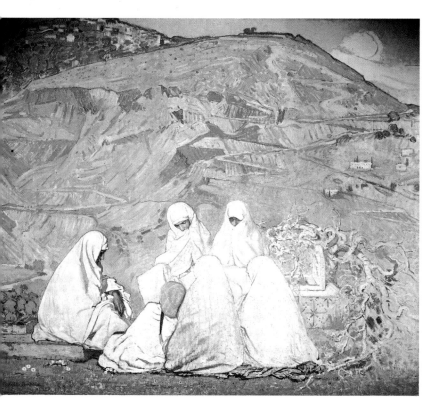

Paul-Elie Dubois. *Peace in Light,* oil on canvas, signed and dated Alger 1923, 110.25 x 127.75 in (280 x 322 cm). Musée National des Arts d'Afrique et d'Océanie, Paris.

Portraits

*U*nless documentary evidence
exists, it is often difficult to
ascertain whether a particular
portrait was done during the artist's
travels or in his home country, for
even eye-witnesses do not always
record reality. Their cultural
backgrounds and, perhaps, their
prejudices, as well as the current
taste and style in art, could all
deform the visions of European
artists in the Eastern world.
Moreover, many painters worked up
their pictures in their studios on their
return with the aid of European
models and accessories, and fading
memories and imagination played a
large part. One cannot even always
differentiate between paintings done
in this way and those by artists who
had never left home but who
followed the fashion for pictures with
an Oriental flavour.

Members of the eighteenth- and
early-nineteenth-century bourgeoisie
or aristocracy who commissioned
their portraits dressed in Eastern
clothes required that the artist paint
their recognisable likenesses. Later,
photography effectively freed artists
from this obligation, and it was they
who could now approach the sitter.
It was no longer a question of
producing a likeness, but a work of
art. This was even more true for
pictures of Orientals, since for the
most part their sitters – whether
really Eastern or only European
models – were anonymous. After all,
pictures of Oriental women, with
their colourful attire and rich
jewellery, were painted in the main
because they were attractive subjects
that pleased collectors. On the other
hand, portraits of important Oriental
men, sultans, viziers, pashas,
khedives or shahs, Turkish,
Moroccan and Persian ambassadors
in Europe or the Algerian leader,
Emir Abd el Kader, emphasised their
rank as well as their likeness, as in
European society portraits. It is
relatively easy for Westerners now

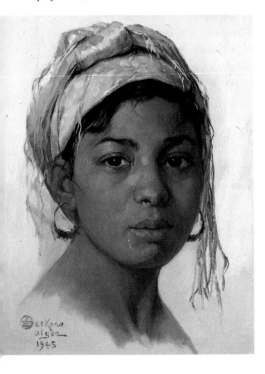

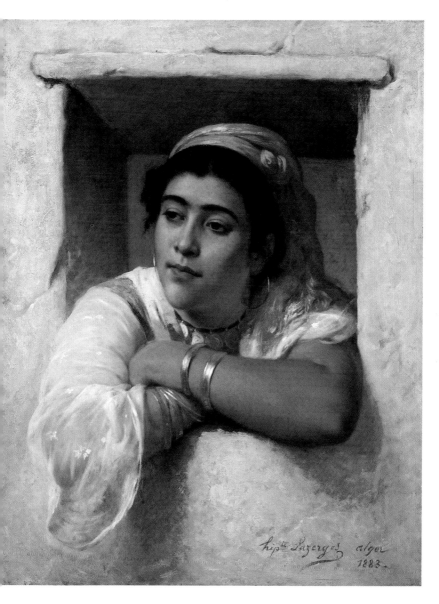

Emile Deckers. *The Silk Scarf,* oil on panel, signed and dated Alger 1945, 12.50 x 10 in (32 x 25 cm). Private collection.

Hippolyte Lazerges. *At the Window,* oil on panel, signed and dated Alger 1883, 27.75 x 21.75 in (70.5 x 55.5 cm). Musée d'Art et d'Histoire, Narbonne.

to differentiate between those portraits of "Eastern" women whose faces are obviously European and those in which the ethnic characteristics are non-Western, but it is possible that at least until the late nineteenth century, the public was unexacting or, perhaps, simply less exposed to people of other countries.

The first part of this study, then, treats those portraits done abroad from life. Many painter-travellers had great difficulty in persuading Muslims to allow themselves to be portrayed. Certainly the modesty of women was one cause, but the reasons for their hostility were more complex than are generally explained. The theological objection to pictorial art stems from a *hadith*, or tradition of the Prophet, not from the Koran itself. While the Prophet prohibited statues as being likely to encourage idolatry, the *hadith* affirms that figurative art is blasphemous, since the sculptor or painter is usurping the creativity of

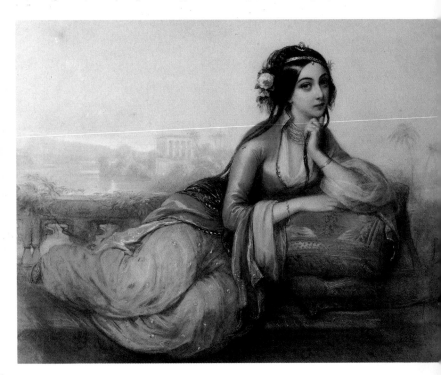

Laura Houssaye de Léoménil. *Princess Hosni Shah,* pastel, signed, 17.25 x 21.25 in (44 x 54 cm). Prince Naguib Hassan Abd Allah collection.

Jean-François Portaels. *The Young Turkish Woman,* oil on panel, 23.25 x 18.25 in (59 x 46.5 cm). Private collection.

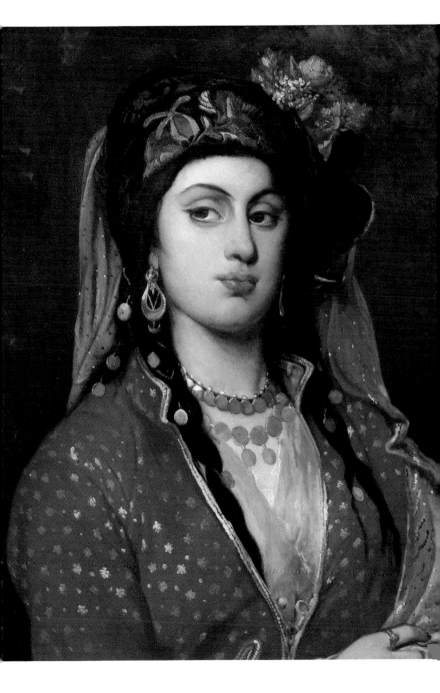

God. The practical acceptance of this prohibition largely depended on the influence of the theologians upon the habits and tastes of Islamic society at any one time, varying from the stern and uncompromising to the lenient. For this reason, Western artists were better received by the Court in Turkey, where figurative miniatures by Muslim artists had been painted for centuries, than in Arab countries, where only calligraphy was allowed, representational painting being forbidden. In addition, the Eastern world entertained a common superstition to the effect that an effigy was not something apart from the person represented, but was a kind of double, damage to which would imply corresponding injury or harm to the living person. Sir Thomas W. Arnold, in *Painting in Islam* (Oxford, 1928), explains that "This fear of thus placing themselves in the power of malevolent enemies made such people refuse to have their portrait taken – or, in modern times, to be photographed – because such a process was regarded as the taking away of a part of their own person." It was therefore amongst the non-Muslim communities in the East, Jews, Copts, Christian Arabs, etc., who had no such interdictions, that many artists found their models. Jean-Etienne Liotard, who lived in Constantinople from 1738 to 1742, painted Levantines and Franks, the word used by the Muslims of the Near and Middle East to designate Europeans and Christian Levantines. In the 1760s, Antoine de Favray almost exclusively painted Phanariots, who were Greeks living in Constantinople's quarter of Phanar. The Phanariots supplied dragomen, or official interpreters, to the embassies and legations, and Europeans would be invited to their often magnificent homes. The women of the richest Phanariot families were splendidly dressed in the Turkish manner, with diamonds, jasmin and roses in their hair, gold-embroidered caftans and diamond- and emerald-studded belt buckles. Under the reigns of Sultan Abdul-Hamid I (1774-89) and Sultan Selim III (1789-1807), foreign artists were freer than ever before to work both in the capital and in the provinces of the Ottoman Empire. Since the traditional clothing was soon to be

Azouaou Mammeri. *Seated Moroccan,* gouache, signed, 18.50 x 24.50 in (47 x 62 cm). Private collection.

Marie Caire-Tonoir. *Woman of Biskra,* oil on canvas, signed, 20 x 21.75 in (51 x 55 cm). Musée National des Arts d'Afrique et d'Océanie, Paris.

André Hebuterne. *Moorish Woman of Oran,* pastel, signed and dated Oran '34, 26.50 x 19.75 in (67 x 50 cm). Musée National des Arts d'Afrique et d'Océanie, Paris.

gradually replaced by European-style dress due to reforms introduced by Sultan Mahmoud II (1808-39), their portraits are all the more precious. In the 1850s, Amadeo Preziosi, who was married to a Greek, did the portraits of Greek women in Constantinople, who were renowned for their beauty. His *Adile Hanoum, a Turkish Lady of Constantinople* (1854, The Victoria and Albert Museum, London) has a simplicity and sensitivity that make it very different from his watercolours of harem women that pandered to the demand at the time for conventional images of a fantasy East. A Russian from a family of great distinction, Prince Grigori Grigorievich Gagarin, painted striking portraits of Caucausian women around 1842, of which several are also in The Victoria and Albert Museum, London. These were reproduced as coloured lithographs in an album published in Paris in 1847. The marvellously vivid and fresh pencil and watercolours done by Eugène Delacroix in Morocco in 1832 are famous; less well-known are ethnographical studies by the Swiss artist Charles Gleyre. He travelled with the American John Lowell, Jr., in 1834-35 in Greece, Turkey and Egypt. Gleyre continued on alone to Syria before returning to Paris, ill and almost blind in 1838. His portraits and figure studies, nearly always executed *in situ*, are now on loan to the Museum of Fine Arts, Boston, from the Lowell Institute. Théodore Chassériau sketched mainly members of the Jewish community when he visited Constantine in 1846; his portrait of a Jewish woman with large, dark eyes (Musée National des Beaux-Arts, Algiers) is both haunting and

melancholic. He also used his mistress Alice Ozy as a model for many of his Algerian paintings. Artists in Persia were few and far between. Those admitted to the court of Mohammad Shah (1834-48), including the Russian Prince Alexis Soltykoff, the Piedmontese Colonel F. Colombari and the Frenchmen Eugène Flandin and Jules Laurens, all did portraits of the shah. The sovereign was so pleased with the one done by Laurens that he asked him to portray his aunt, Farah

Georges Gasté. *Portrait of a Woman*, oil on panel, signed and dated Caire 1899, 16 x 13 in (41 x 33 cm). Courtesy of the Galerie Antinéa, Paris.

Khânoum. The sitting was a memorable one. Concealed by draperies held up by her servants, the princess steadfastly refused to unveil. "In the face of the adamancy, the artist's earnest entreaties and supplications remained unavailing. At long last, however, she cast off her chador, a species of great cloak that completely hid her from view, and emerged in all her full magnificence." (L.H. Labande, *Jules Laurens,* Paris, 1910).

From the 1890s, French artists in Algeria, particularly those who were frequent visitors or lived there permanently, such as Etienne Dinet, Alfred Chataud and Francisque Noailly, did portraits that brought out the character and emotions of their sitters. Even then, artists did not always find it easy to persuade subjects to pose. The Belgian Henri Evenepoel, who was wintering in Blidah in 1897-98 for reasons of poor health, largely used photographs rather than sketches to paint his highly original works. This might possibly have been the case for a portrait of a beguilingly smiling girl by Georges Gasté. This must have been particularly popular, since he painted several variants over a period of seven years, variously inscribed Algiers, Bou-Saâda and Cairo. This method was frequent in colonial postcards, for which the same model would be photographed wearing costumes of different ethnic origins. Nineteenth-century academic portraits of "Eastern" women painted in studios were intended above all to please, so they were almost without exception of beauties. The numerous English and Continental portraitists include Hugues Merle, Emile Eisman-Semenowsky, Jan Portielje, Léon

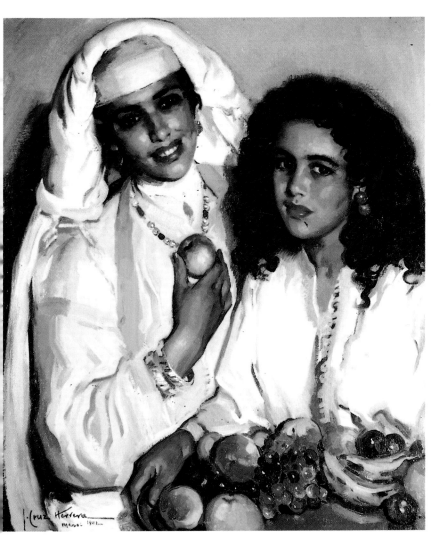

José Cruz-Herrera. *Young Moroccans with Fruit,* oil on canvas, signed and dated Maroc 1942, 30 x 25.75 in (76 x 65.5 cm). Private collection.

Herbo, Frédéric-Pierre Tschaggeny, Cesare Dell' Aqua, Pierre-Olivier-Joseph Coomans, Gustave de Jonghe, John Absolon, Alice M. Chambers and Ernest Normand. Many made only a token attempt to paint convincingly Oriental-looking women. In an attractive painting by the English artist Sophie Anderson, a woman in a pretty caftan and a sequinned head scarf has the appearance of a Tunisian, but the

Charles Landelle. *Ouled-Naïl, Biskra,* pastel, signed with initials and inscribed Biskra, 20.75 x 18 in (53 x 46 cm). Private collection.

artifical pose – her arm is held over her head – makes it clear that it is a studio portrait. There is no ambiguity about Léon Comerre's work. He put his European sitters in Eastern clothes, stuck large poppies behind their ears, and posed them against a simulated background of the Alhambra. The identities of some of these are known, such as *Mademoiselle Journet en Orientale* and *Marcelle Souty* (1916). In the majority of these studio portraits – for example, in Edouard Manet's *Sultana* (1870, E.G. Bührle Foundation, Zurich) – the sitters appear to be oblivious of the viewer. However, many of them are simpering and self-consciously playing with a fan, a flower or their hair. Many travellers brought back costumes and accessories, so that the portraits by Benjamin-Constant, Gaston Saintpierre, Emile Vernet-Lecomte, Jean Portaels, Charles Landelle, Jean-Léon Gérôme and Frederick Arthur Bridgman have an atmosphere of authenticity. After his return to France, Emile Bernard, who had painted many portraits during his long stay in Egypt, continued to portray young women in turbans, notably his favourite model, Armène Ohamien. Curiously enough, Auguste Renoir's pictures of the 1870s correspond more to a convential imagery of the East than do those painted after his trips to Algeria in 1880 and 1881. He used his experience of light and colour as a departure point for portraits such as *Algerian Girl* (1881, Boston Museum of Fine Arts), in which the exotic content is of secondary importance.

In Morocco, even during the time of the French protectorate, few artists could travel without a military

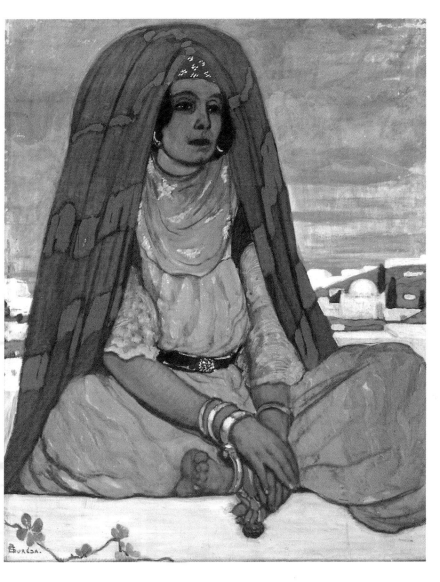

André Suréda. *Seated Berber on a Terrace,* tempera, signed, 25 x 20 in (63.5 x 51 cm). Musée Lambinet, Versailles.

escort. Furthermore, it was hard to persuade Muslims to be painted, since the country was proudly traditionalist. Cosmopolitan Tangiers was comparatively freer, although Henri Matisse, who paid his first visit there in 1912, was only able to pose Jewish women and prostitutes. He painted some remarkable works, and his *Zorah on the Terrace* (1913, Pushkin Museum, Moscow), in which a kneeling woman floats against a turquoise and blue background, is without doubt the most avant-garde Orientalist portrait of its time. At once bare and rich, it seems to be a

dream or a vision rather than an actuality. Although Louis-Auguste Girardot was painting portraits of Muslim women of Tangiers from 1887 and, from 1904, of Tetuán, these probably owe a lot to imagination. On the other hand, Lucien Lévy-Dhurmer, who was doing hauntingly evocative pastels and oils in Marrakesh from around 1901, chose unveiled Berbers or veiled women on outings for his models.

As a result of a governmental commission, François de Hérain published three volumes of etched portraits entitled *Types Marocains* (1931-33). Another album, *Costumes du Maroc*, by the painter and photographer Jean Besancenot, was the result of years spent recording traditional costumes, adornments and tattooings. The original plates are now in the Bibliothèque Royale in Rabat. During the 1930s, other artists in Morocco, Georges Klein and Christian Caillard, for instance, painted portraits that were often full-length and whose austerity contrasts with the brilliant colours of Roger Bezombes's portraits, such as *Moroccan Woman* (1938, Musée National d'Art Moderne, Paris) and the expansive richness of José Cruz-Herrera's works, filled with fruit and flowers. In Tunisia, Albert Aublet, president of the Société des Artistes de Tunis, did portraits of Arab women that conformed to the old stereotyped image of Orientals as being plump, indolent and enticing. They are in complete contrast with the sensitive and humane portraits by Alexandre Roubtzoff who, from his arrival in Tunis in 1914 until his death in 1949, recorded the people and landscapes of the country he so passionately cared about.

Paul Leroy. *Young Girl with a Tortoise,* oil on canvas, signed and dated 1885, 24.50 x 19.75 in (62 x 50 cm). Private collection.

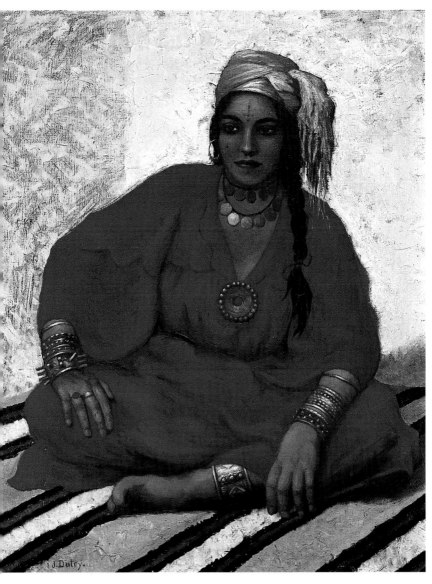

Jean Dutey. *The Relaxed Pose,* oil on
canvas, signed, 32 x 25.50 in (80 x 65 cm).
Private collection.

There was a larger concentration of artists in Algeria than in any of the other Oriental countries. Not only was this French colony (later *départements*) conveniently located not too far from Marseilles, but by the early twentieth century there had emerged a lively artistic movement in which North-Africa-born Western painters played an active role. This meant that the stylistic range and variety of portraits was vast. The pictures of Algerian women by such artists as René Ricard, Salomon Taïb, Renée Tourniol, Joseph Sintès, Marcelle Rondenay and the Belgian Emile Deckers were nearly always pictorially conventional. Their works were exhibited in the galleries and at the Salons in Algiers but were popular above all in Europe. Another Belgian artist, Edouard Verschaffelt, severed all contact with Europe, however, when he settled in Bou-Saâda. Much appreciated today by collectors, he often painted appealing young girls as well as portraits of his own Algerian family. At the same time, there were numerous artists painting in a more modern manner, including Marius de Buzon, André Suréda, Jean Bouchaud, Emile Aubry, Jules Migonney, Paul-Elie Dubois, André Hebuterne, Roger Nivelt, Pierre Deval, Léon Cauvy, Yvonne Kleiss-Herzig, Maurice Bouviolle and the renowned Albert Marquet, who visited Algiers a number of times during the 1920s and 1930s and Laghouat in 1929. Amongst the most unusual of these portraits are the large paintings dating from 1924 and 1925 by Jean Lurçat, the result of a journey in the Sahara. Two of these, both entitled *Algerian Woman*, in which a woman stands with one hand behind her head, in strikingly patterned dress, are simplified and analytical. The pictures show the artist's concern with decorative elements that was to lead him to foster the renaissance of tapestry weaving. Other unique portraits of

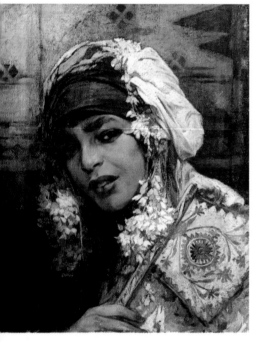

Jules van Biesbroeck. *Young Woman with a Fan*, oil on cardboard, signed, 18 x 15 in (46 x 38 cm). Private collection.

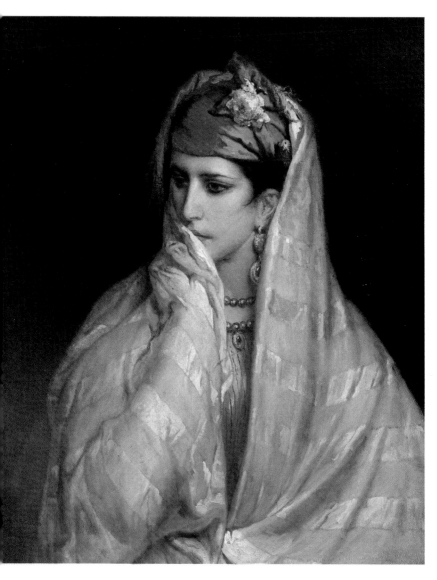

Jean-François Portaels. *Portrait of a North African Girl,* oil on panel, signed and dated Tanger 1874, 26.75 x 23.25 in (73 x 59 cm). Musée Communal des Beaux-Arts, Charleroi.

women in patterned dresses are those by Baya. Her poetical, naïve gouaches were discovered by Aimé Maeght, who, in 1947, launched the work of this Kabyle autodidact in his Parisian gallery.

Since the exotic was an everyday experience for the French living in Algeria, they preferred on the whole not only to buy paintings that reminded them of the metropolis – scenes of Normandy cows or Breton peasants – but also to adorn their homes with portraits of themselves rather than with those of Arabs. Artist such as Lucienne Capdevielle, Pierre Segond-Weber and Emile Deckers catered for this market. As for the caricaturists Charles Brouty, Salomon Assus and Hans Kleiss, they portrayed not only denizens of the casbah and European hoi polloi, but also leading citizens. The remarkable draughtsman Jean Launois did many fine portraits of Arab women. He also frequented the brothels of Algiers to sketch the girls and their clients; his pastel of a flaccid, hard-bitten French madam, Nathalie, is worthy of Toulouse-Lautrec.

The large majority of the portraits done in the Maghreb are set against backgrounds of views of towns, Oriental carpets or faience tiles, which situated the models in their country of origin. Other painters did uncompromising portraits devoid of exotic trappings: Lucien Mainssieux, in *Girl in Gafsa* (1923), *Zohra* (1924) and *Fréha* (1925); André Hambourg, in *The Blue Women* (1938) and *Judith of Erfoud* (1938); and Simon Mondzain, in *Little Jewish Girl Ghardaïa* (1945).

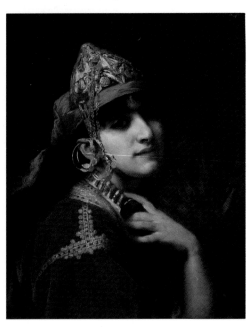

Gaston Saintpierre. *Halima,* oil on canvas, signed, 22 x 18 in (56 x 46 cm). Musée d'Art et d'Histoire, Narbonne.

Acknowledgments

Many museum curators and staff, auctioneers, art experts, specialists, dealers, collectors, university students, as well as artists and artists' families, have kindly offered me valuable help with photographs and information. I would like to express my thanks to Gerald M. Ackerman, Maîtres Ader Tajan, Lucien Arcache, Françoise Baligand (Musée de la Chartreuse, Douai), Koudir Benchikou, Roger Bezombes, Paul Boglio (Association Artistique Alexandre Roubtzoff), M. Bouadani, Denise Brahimi, the Caisse Générale d'Epargne et de Retraite (Brussels), Jean-Pierre Chalon, Maîtres Gautier, Goxe and Belaïsch Jérôme Coignard, David Darmon Olivencia, Marie-Christine David, Dominique Durand, Hélène Farey-Nivelt, The Fine Art Society, Ilene Susan Fort, Jacques Fricker, Galeria II di Quadri, Galerie Arlette Gimaray, Galerie Berko, Galerie Intemporel, Galerie Nataf, Catherine Gendre (Musée Lambinet, Versailles), Christopher Gibbs Ltd., Maîtres Gros and Delettrez, André Hambourg, Julian Hartnoll, Charles Jerdein, Marie and Guy Joubert, Caroline Juler, Mohamed Habib Krifa, Marc Lambrechts, Alain Latreille, Alain Lesieutre, Rachel Liberman, Briony Llewellyn, Renée Loche (Musée d'Art et d'Histoire, Genève), Brian MacDermot (Mathaf Gallery), Henri Marchal, Djillali Mehri, Christian Meissirel Fine Art, Charles Newton (The Victoria and Albert Museum, Londres), Mustapha Orif, Philippe Perrault, Richard Green Galleries, Irfan Saruhan, Jean Soustiel, Maître Sylvie Teitgen, Yves Thoraval, Jean Trombert, Daniel Vella, Françoise Zafrani, Christophe Zagrodski.

Contents

INDEX

Allan, Sir William : *Slave Market in Constantinople,* p. 171.

Allom, Thomas : *The Favourite Odalisque,* or *The Odalisque,* or *Favourite of the Harem,* p. 33.

Aureli, Giuseppe : *Oriental Beauty,* p. 22.

Bakst, Léon : *Costume Design for an Odalisque in the Ballet Schéhérazade,* p. 13.

Bartolini, Filippo : *Women in a Courtyard, Tlemcen,* p. 38.

Benjamin-Constant : *Evening on the Terraces, Morocco,* p. 49 ; *The Scarf Dance,* p. 88 ; *The Sharifas,* p. 133.

Bernard, Emile : *Hashish Smoker,* p. 56 ; *In the Harem,* p. 25.

Berteaux, Hippolyte : *Fountain in Constantinople,* p. 140.

Beyle, Pierre-Marie : *Bridal Finery, Algeria,* p. 89.

Bezombes, Roger : *Moroccan Bride,* p. 96.

Biesbroeck, Jules van : *The Discussion,* p. 59 ; *Entering the Hamman,* p. 64 ; *Young Woman with a Fan,* p. 186.

Boiry, Camille : *Moroccan Market,* p. 143.

Bompard, Maurice : *Waiting,* p. 136.

Boschi, Achille : *The Harem,* pp. 38-39.

Bouchard, Paul-Louis : *After the Bath,* p. 69.

Bouviolle, Maurice : *The Blue Staircase,* p. 61.

Bredt, Ferdinand-Max : *Dreaming,* p. 120.

Bridgman, Frederick Arthur : *The First Steps,* p. 42 ; *Feast of the Prophet at Oued-el-Kebir,* p. 110 ; *The Reading Lesson,* p. 151 ; *The Pirate of Love,* p. 162.

Buzon, Marius de : *Romance in the Algerian Springtime,* p. 116.

Caire-Tonoir, Marie : *Woman of Biskra,* p. 179.

Carré, Ketty : *The Servants,* p. 30.

Carré, Léon : *The King was not Displeased to Listen to Scheherazade's Tale,* p. 15 ; *And he Led me into his Finely-coloured Tent,* p. 117.

Cauvy, Léon : *Abundance,* p. 135 ; *On the Wharf : the Admiralty of Algiers,* p. 138 ; *The Outing, Algiers,* p. 141.

Cercone, Ettore : *Examining Slaves,* p. 166.

Chassériau, Théodore : *Bathing in the Seraglio,* p. 76 ; *Moorish Woman Nursing her Infant, and an Old Woman,* p. 150.

Chataud, Alfred : *After the Circumcision,* p. 111.

Chlebowski, Stanislas von : *Purchasing a Slave, Constantinople,* p. 167.

Clairin, Georges : *Costume for an Eastern Fête,* p. 10 ; *Two Ouled-Nail Women,* p. 132.

Comerre, Léon : *Poppies,* p. 4.

Cormon, Fernand : *The Deposed Favourite,* p. 163 ; *Jealousy in the Seraglio,* p. 164.

Cruz-Herrera, José : *The Puppet,* p. 52 ; *Young Moroccans with Fruit,* p. 181.

Darjou, Alfred : *Gugglet Dance,* p. 127.

Debard, Myrto : *Nocturnal Dance,* pp. 62-63.

Debat-Ponsan, Édouard : *Massage, Hammam Scene,* p. 73.

Deckers, Émile : *The Silk Scarf,* p. 174.

Dehodencq, Alfred : *Jewish Bride in Morocco,* p. 95.

Delacroix, Eugène : *Death of Sardanapalus,* p. 165.

Delahogue, Eugène : *Marketplace in Tangiers,* p. 142.

Dicksee, Sir Frank : *Leila,* p. 50.

Dillon, Frank : *Appartment in the Harem of the Sheikh Sâdât, Cairo,* p. 29.

Dinet, Étienne : *Festival Dress,* p. 100 ; *The Djouak,* p. 113 ; *Friday in the Cemetery,* p. 172.

Dubois, Paul-Émile : *The Amzad Player,* p. 62 ; *Tinguelouz's Family in the Hoggar,* or *Tinguelouz, Noble Woman in the Hoggar,* p. 160 ; *Peace in Light,* p. 173.

Dufy, Raoul : *Couscous Served at the Residence of the Pasha of Marrakesh,* p. 105.

Dulac, Edmund : *The Queen of Sheba,* p. 14.

Dutey, Jean : *Preparing the Tea,* p. 58 ; *The Relaxed Pose,* p. 185.

Edy-Legrand, Edouard : *The Two Friends,* p. 27.

Eisenhut, Ferencz Franz : *The Story Teller,* p. 44.

Ernst, Rudolf : *Woman on a Terrace in Morocco,* p. 21 ; *The Hammam,* p. 66 ; *After the Bath,* p. 77 ; *The Manicure,* p. 82 ; *The Mirror,* p. 83 ; *The Favourite,* p. 115 ; *Women Spinning, Morocco,* p. 156 ; *Rose-picking,* p. 157.

Estienne, Henry d' : *Young Arab Girl Carrying the Coffee,* p. 26 ; *Arab Girl Carrying Bread,* p. 144 ; *Preparing Couscous,* p. 147.

Fabbi, Fabio : *Procession in Cairo,* p. 98.

Fabres y Costa, Antonio : *Moorish Courtyard,* p. 24.

Faléro, Luis Riccardo : *The Bewitcher,* p. 129.

190

Favray, Antoine de : *Madame Vergennes in Oriental Costume,* p. 8.
Fragonard, Jean-Honoré : *The Pasha,* p. 5.
Frère, Théodore : *Old Cairo,* p. 158.
Gasté, Georges : *Portrait of a Woman,* p. 180.
Gérôme, Jean-Léon : *Excursion of the Harem,* p. 32 ; *The Narghile Lighter,* p. 68 ; *The Great Bath at Brusa,* pp. 70-71 ; *Steam Bath,* p. 75 ; *Sword Dance in a Café,* p. 118 ; *Woman of Cairo at her Door,* p. 119 ; *Woman of Cairo,* p. 119.
Girardet, Eugène : *A Bridal Procession in Southern Algeria,* pp. 90-91.
Girardot, Louis-Auguste : *Spinning,* p. 155.
Giraud, Eugène : *Interior of an Egyptian Harem,* p. 28 ; *Terrace on the Banks of the Nile,* p. 49.
Goodall, Frederick : *A New Light in the Harem,* p. 43.
Guérard, Eugène : *Harem Scene,* p. 122.
Hamdy Bey, Osman : *Girl Arranging Flowers in a Vase,* p. 25 ; *Door of the Great Mosque, Brusa,* p. 31.
Hardy, Dorofield : *Dreaming,* p. 41.
Hébuterne, André : *Moorish Woman of Oran,* p. 179.
Houssaye de Léoménil, Laura : *Princess Hosni Shah,* p. 176.
Hunt, William Holman : *A Street Scene in Cairo : the Lantern Maker's Courtship,* p. 126 ; *The Afterglow in Egypt,* p. 159.
Huysmans, Jan-Baptist : *The Fortune-Teller,* p. 36 ; *Tending Baby,* p. 43 ; *The Beauty Spot,* p. 81 ; *Jugglers in the Harem,* p. 94.

Ingres, Jean-Auguste-Dominique : *Turkish Bath,* p. 67 ; *Odalisque with Slave,* p. 133.
Izart, Marie-Antoinette : *The Cup of Coffee,* p. 51.**Jonghe, Gustave de :** *Idleness,* p. 20.
Kleiss-Herzig, Yvonne : *The Bath,* p. 78 ; *Moroccan Interior,* p. 79 ; *Returning from the Market,* p. 161.
Landelle, Charles : *Ouled-Naïl, Biskra,* p. 182.
Lazerges, Hippolyte : *The Love Token,* p. 137 ; *At the Window,* p. 175.
Leblanc, Théodore : *Haroufoah, Muslim Bride,* p. 97 ; *Muslim Woman's Visiting Costume for a Marriage,* p. 97.
Lecomte du Nouÿ, Jean : *White Slave,* p. 124.
Leroy, Paul : *Arab Dance,* pp. 46-47 ; *Woman and Children in a Saharian Interior, Algeria,* p. 148 ; *Young Girl with a Tortoise,* p. 184.
Lévy-Dhurmer, Lucien : *Evening Outing,* or *Women on an Outing, Morocco,* p. 53 ; *Moroccan Woman Spinning,* p. 152.
Lewis, John Frederick : *In the Bey's Garden, Asia Minor,* p. 35 ; *An Intercepted Correspondence,* pp. 130-131 ; *The Hosh (courtyard) of the House of the Coptic Patriarch, Cairo,* p. 146.
Lino, Gustave : *Moorish Woman,* p. 139.
Liotard, Jean-Etienne : *Presumed Portrait of the Duchess of Coventry,* p. 11 ; *Frankish Woman in Turkish Dress and her Servant,* p. 74.
Loo, Carle van : *The Grand Turk Giving a Concert to his Mistress,* pp. 6-7.

Lucas-Robiquet, Marie-Aimée : *Southern Algerian Interior,* p. 153.
Majorelle, Jacques : *A Day of Pilgrimage,* p. 106 ; *Moroccan Dancers at Telouet,* p. 107 ; *The Alamats,* or *Moroccan Dolls,* or *The Alamates, Women with Dolls,* p. 108 ; *Carpet Sellers, Souk el Khemis, Marrakesh,* p. 161.
Mammeri, Azouaou : *Seated Moroccan,* p. 178.
Migonney, Jules : *Arab Woman Holding a Narghile,* p. 57 ; *The Moorish Bath,* p. 73.
Mowbray, Henry Siddons : *The Harem,* p. 17.
Pavil, Anatole Elie : *On the Terrace,* p. 60.
Pavy, Philippe : *The Serving Girl,* p. 145.
Pickersgill, Henry William : *Portrait of James Silk Buckingham and his Wife in Arab Costume of Baghdad of 1816,* p. 9.
Pilny, Otto : *Dancer with a Tambourine,* p. 99.
Portaels, Jean-François : *Woman with Jewellery,* p. 84 ; *The Young Turkish Woman,* p. 177 ; *Portrait of a North African Girl,* p. 187.
Pujol de Guastavino, Clemente : *Musician,* p. 45.
Racim, Mohammed : *Dancers (Old Algiers),* p. 104.
Raffaëlli, Jean-François : *Black Entertainer,* p. 93.
Renoir, Auguste : *Woman of Algiers,* or *Odalisque,* p. 114.
Richter, Edouard : *Eastern Dancer,* p. 99.
Ricketts, Charles : *Costume Design for the Play Judith,* p. 12.
Rosati, Giulio : *Gossiping,* p. 40 ; *Inspecting the New Arrivals,* p. 168.

Roubtzoff, Alexandre : *Mabrouka,* p. 80 ; *Djamilla and Fatima,* p. 154.
Roybet, Ferdinand : *Keeping the Marabou Amused,* p. 54 ; *Trying on Finery,* p. 85.
Saintpierre, Gaston : *The Oleander Song,* p. 23 ; *Chetahate, (The Dancers) : Women's Fête in an Arab Wedding in Tlemcen, Oran Province,* p. 101 ; *Halima,* p. 188.
Sargent, John Singer : *Ambergris Smoke,* p. 65.
Simonetti, Ettore : *The Rug Merchant,* p. 34 ; *The Fortune-Teller,* p. 37.
Simoni, Gustavo : *Resting on the Terrace,* p. 48.
Simon, Mario : *Odalisque,* p. 19.
Stiepevitch, Vincent : *The Favourite,* p. 128.
Suréda, André : *In the Palm-grove,* p. 56 ; *Festival,* p. 109 ; *Idyl,* p. 134 ; *Seated Berber on a Terrace,* p. 183.
Tapiro y Bara, José : *Preparations for the Marriage of the Sherif's Daughter,* p. 87.

Tissier, Ange : *An Algerian and her Slave,* p. 55.
Trouillebert, Paul-Désiré : *The Harem Servant,* p. 123.
Vanmour, Jan-Baptiste : *Reception in a Turkish Harem,* pp. 102-103.
Vernet, Horace : *Capture of Abd el Kader's Retinue by the Duc d'Aumale,* p. 169.
Verschaffelt, Edouard : *Family Scene,* p. 149.
Vien, Joseph Marie : *Queen Sultana,* p. 6.
Wontner, William Clarke : *Safie, One of the Three Ladies of Bagdad,* p. 121.

PHOTOGRAPHIC CREDITS